Landscape Creation 3

Feel the "afternoon breeze"

Published by Dainippon Kaiga

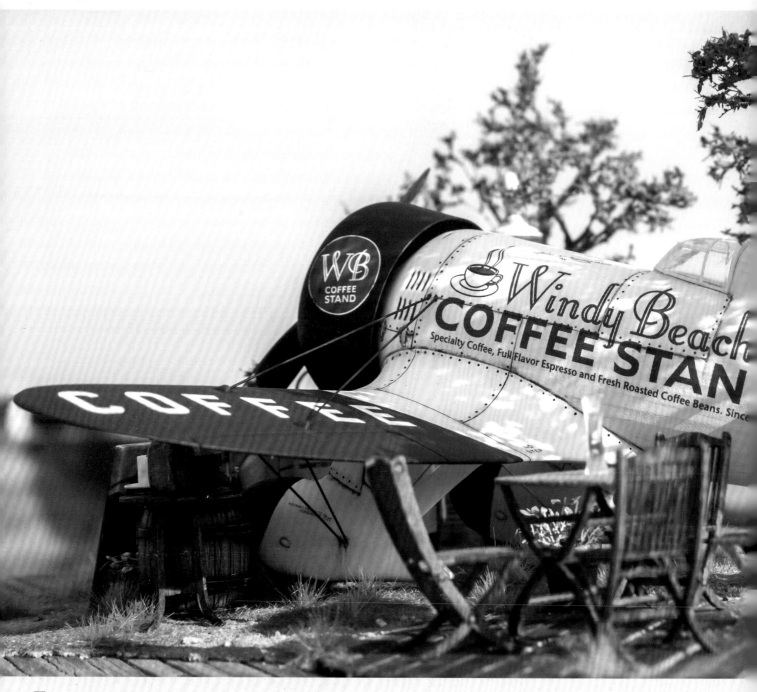

　　「景觀模型的創造與製作」系列推出第3冊！本次的內容主要是以汽車、飛機等交通工具為創作題材的作品。我本身很喜歡汽車，所以作品經常以汽車為創作題材。透過車身的鏽蝕表現出使用已久的感覺，或藉由車款呈現出復古感等等，只要在情景模型當中放置一輛汽車，就能一口氣展現出情景模型包含的各種資訊。就這個意義而言，汽車的確是我在創作時不可或缺的小道具。

　　另外，我在作品當中創作的汽車或是飛機，大多都是某個地方的店家營業用車，所以車身通常會有巨大而明顯的店名。再加上身為平面設計師的特質，我很喜歡琢磨文字字體，並透過文字風格使作品的氛圍更逼真，創作書店模型時就要做得像一間真正的書店，要做衝浪用品店就要打造出衝浪用品店的氛圍。在作品之中加入滿滿的文字排版趣味，也是打造景觀模型的樂趣之一。讀者若能在閱讀本書時注意到這一點，我也會感到相當開心。（奧川）

「擷取風景」的情景模型製作達人──奧川泰弘
帶領讀者進入以高超的美感及技術
打造出的昔日美國世界

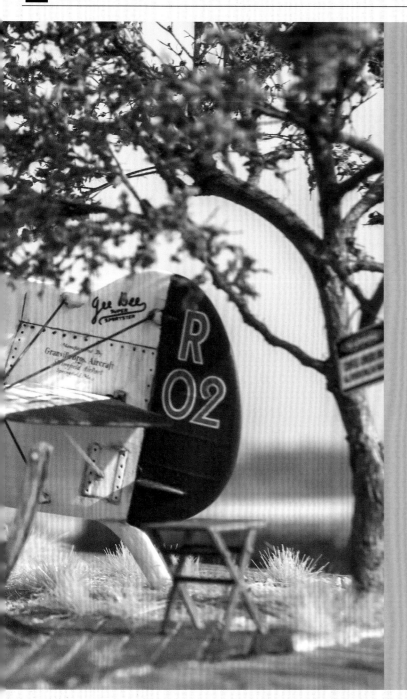

Contents
【目次】

奧川泰弘
Yasuhiro Okugawa

1964年出生。情景模型創作家、平面設計師。小學時便對模型感興趣，1993年左右開始以軍事情景模型的作品參加各種模型比賽。1996年於英國模型大賽榮獲優勝。目前陸續創作以美國風景與生活為題材的情景模型作品。創立模型品牌「Doozy Modelworks」，其個人作品亦發表於該品牌的官方網站。
(http://doozymodelworks.com/)

解 析 奧 川 泰 弘 的 工 作 室
Yasuhiro Okugawa's Workshop

奧川先生的立體透視模型作品飽含著濃厚的鄉愁與溫暖，那麼創作這些作品的工作室究竟長得如何呢？工作室內部的擺設讓奧川先生在追求
工作效率的同時，也展現出他個人獨特的堅持。首先就讓我們來參觀工作室的內部模樣，以及奧川先生在創作時不可或缺的各種愛用工具。

illustrated by Yasuhiro Okugawa

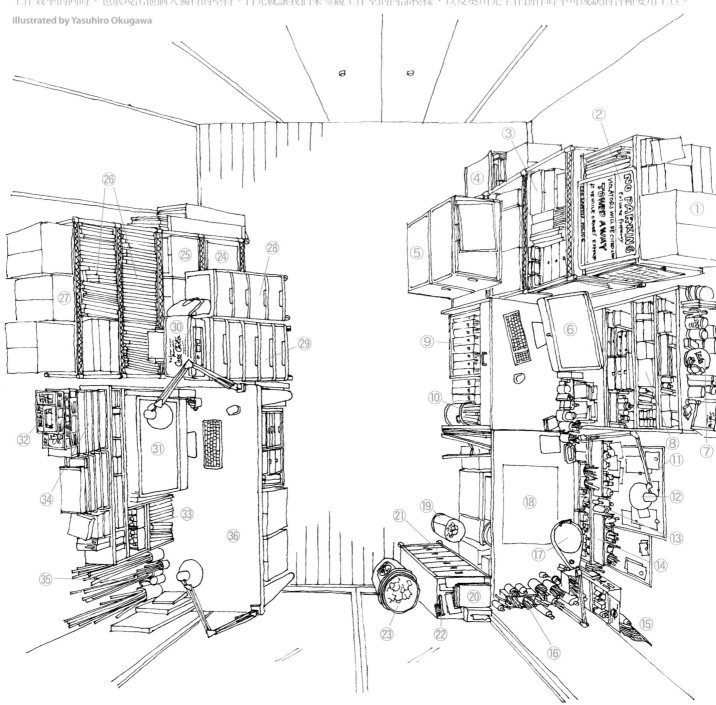

這裡是奧川先生的工作室。工作室內擺著兩張並排的工作桌，有條不紊地收納奧川先生創作時
使用的材料、工具，以及從前作品相關的資料或為了興趣而蒐集的雜貨等等。製作模型的工具
或材料庫存品等也都分門別類地整理好。①紙箱裡放著各家製造商的樹脂製的配件零件。②這
裡收納大小不一的抽屜及文件夾，看起來不是很整齊，所以用漂亮的板子擋起來。③放不進桌
子底下的文件就放在這裡。④製作立體透視模型底座使用的古董化妝版等等，以及零碎的板
材。⑤塑膠製折疊收納箱。裡面放了 Doozy 剩下的 GK 模型用轉印貼紙等等。⑥25 吋的 Mac。
安裝了 Illustrator，繪圖時使用。⑦櫃子最上層放了美國雜貨。⑧樹脂製的鐵桶或木桶等小配
件，或是裁切好的塑膠棒等等，各種小巧的材料都分門別類地收在這裡。⑨與目前為止製作的
作品有關的文件（紀錄底座尺寸、使用材料等等的紙條、用於轉印貼紙的草稿圖等等），依照
作品分類、歸檔於各資料夾。⑩整齊收納了圓棒等短棒狀材料的罐子。⑪用磁貼將與作品相關
的便條紙固定在白板上。⑫懸臂式 LED 燈。白光。⑬桌面前方整齊擺置鎅刀、抹刀、鉗子、
塗料等各種工具。⑭工具立架是從美國製的古董架拆下來的抽屜。⑮工作桌旁邊是插著美國國
旗的空啤酒罐。⑯桌子的右手邊也擺滿了模型用的塗料及工具。⑰懸臂式 LED 燈，打開中
間的蓋子就能當作放大鏡使用。⑱切割墊，極為普通的用品。⑲小垃圾桶，工作中產生的垃圾

或灰塵都可以立刻丟在這裡。⑳目前正在製作的模型資料就放在伸手可及的地方。㉑存放
Copic、Humbrol、AK interactive 等塗料、圖釘、夾子等所有小東西的抽屜。㉒掃垃圾用的刷
子。㉓當成大垃圾桶使用的美國「76」加油站的 PE 塑膠桶。㉔放不進櫃子裡的雜貨就收在這
裡。㉕收納噴槍空壓機的電線或說明書、外包裝等 Doozy 製品的樹脂製配件以外的物品。㉖
資料書籍，除了模型書以外，還有雜誌、美國風景寫真集、Trad 風格／Ivy 風格的服裝資料等
各種領域廣泛的內容。㉗收納模型組、累積的英文報紙（用來當作拍攝時的背景或模型的資
料）的箱子㉘ Ceramcoat 或 Acrylicos Vallejo 的壓克力塗料、沙子或小草等立體透視模型用的
材料，都在這個抽屜裡。㉙抽屜裡收納了浪板形狀的塑膠板或小配件、做成花盆的人物模型
用排氣口零件或蝕刻片、袖珍模型屋配件等等。㉚ Epson 的彩色印表機。㉛27 吋的 iMac。
這台 Mac 為一般電腦用途，用來上網等等。㉜一部分的庫存模型組。最上層是青島文化教材
社的音響塑膠模型。㉝庭園、字體、Hot rod 改裝車等喜歡的資料書籍就放在電腦旁。㉞雷射
裁切而成的椅子、桌子等紙製或木製的情景用材料。㉟用來製作房屋外牆等等的長條狀薄木
板。當成輔助工具桌使用的木製餐桌。

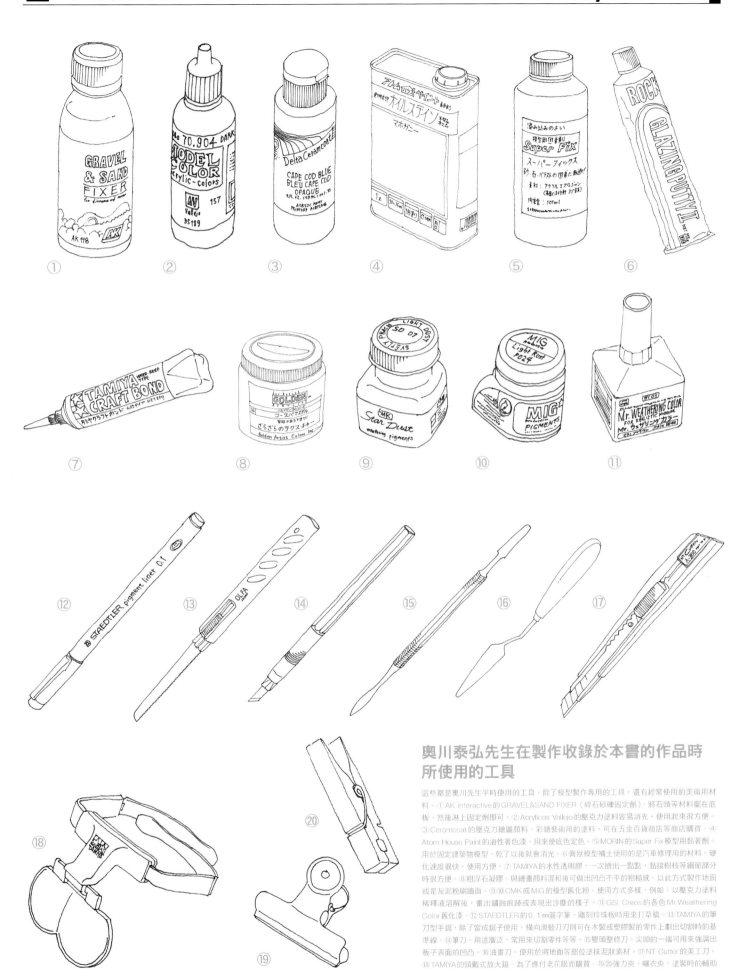

奧川泰弘先生在製作收錄於本書的作品時所使用的工具

這些都是奧川先生平時使用的工具。除了模型製作專用的工具，還有經常使用的美術用材料。①AK interactive的GRAVEL&SAND FIXER（碎石砂礫固定劑），將石頭等材料擺在底板，然後淋上固定劑即可。②Acrylicos Vallejo的壓克力塗料容易消光，使用起來很方便。③Ceramcoat的壓克力繪圖顏料。彩繪藝術用的塗料，可在五金百貨商店等商店購買。④Atom House Paint的油性著色漆，用來使底色定色。⑤MORIN的Super Fix模型用黏著劑，用於固定建築物模型。乾了以後就會消光。⑥膏狀模型補土使用的是汽車修理用的材料。硬化速度很快，使用方便。⑦TAMIYA的水性透明膠，一次擠出一點點，黏接樹枝等細部部分時很方便。⑧粗浮石凝膠。與繪畫顏料混和後可做出凹凸不平的粗糙感。以此方式製作地面或是灰泥粉刷牆面。⑨⑩CMK或MiG的模型舊化粉。使用方式多樣，例如：以壓克力塗料稀釋液溶解後，畫出鏽蝕痕跡或表現出沙塵的樣子。⑪GSI Creos的各色Mr.Weathering Color舊化漆。⑫STAEDTLER的0.1mm簽字筆。雕刻珍珠板時用來打草稿。⑬TAMIYA的筆刀型手鋸，除了當成鋸子使用，橫向滑動刀刃可在木製或塑膠製的零件上劃出切割時的基準線。⑭筆刀。用途廣泛，常用來切割零件等等。⑮雙頭整修刀。尖頭的一端可用來強調出板子表面的凹凸。⑯油畫刀。使用於將地面等部位塗抹泥狀素材。⑰NT Cutter的美工刀。⑱TAMIYA的頭戴式放大鏡。為了應付老花眼而購買。⑲⑳強力夾、曬衣夾。塗裝時的輔助工具。如果是木製的話，夾子前端得事先加工才方便進行作業。

製作令讀者腦海浮現出故事的
大型立體透視模型

Creating the big size diorama to make you imagine the story.

這一件作品「Hang Loose!」以1/32的比例再現整棟建築，做出了唯有大型立體透視模型可見的外觀。沿海咖啡廳的壁板紋理、乾燥的沙地觸感、金龜車的質感以及人物模型等等，透過立體透視模型的建築，表現出這間咖啡店的選址、場地的氛圍、臨近大海的清爽空氣感。這件作品雖是大型立體透視模型，在各種要素以及數量的配置上卻沒有一絲多餘，整體的感覺非常協調，交織出一篇故事。雖然是容易顯得笨重的大型立體透視模型，各種要素的疏密程度及配置卻掌握得很好，以整個情景模型表現出一種氛圍，這一點正證明了立體透視模型創作家奧川先生擁有的高超本領。各位在這一件作品看見了什麼樣的故事呢？

Wavy seashore summer afternoon
Cicada is busy making loud noises as usual
Looking from the car window, white waves are splashing
Afternoon breeze gently caress me, no need of air conditioning
Let's stop the car at UMI CAFÉ and go into the water
Master said he will be going out to get groceries but is he already back now?
Miyuki helping out the master might be angry busy sorting everything by herself
But I like her angry face after all
I want to tell her that I like her, but no courage to say
Now the car radio started to play pops best hit 10
oh, not Careless Whisper again
You go for Huey Lewis, here
Never mind, just get on the wave
How about going out shopping to get something to wear
Summer Jacket in madras check
Same coordinate that was in the mens fashion magazine Mens Club
I like that style
OK, Miyuki is not upset at all
Oh there is also Kenta in the café
Why don't you come with me this afternoon to go shopping to get clothes

I will be dating Miyuki
Didn't I tell you that we started dating......

My words are lost with the sound of the wind

1/32比例模型（2015年製作）

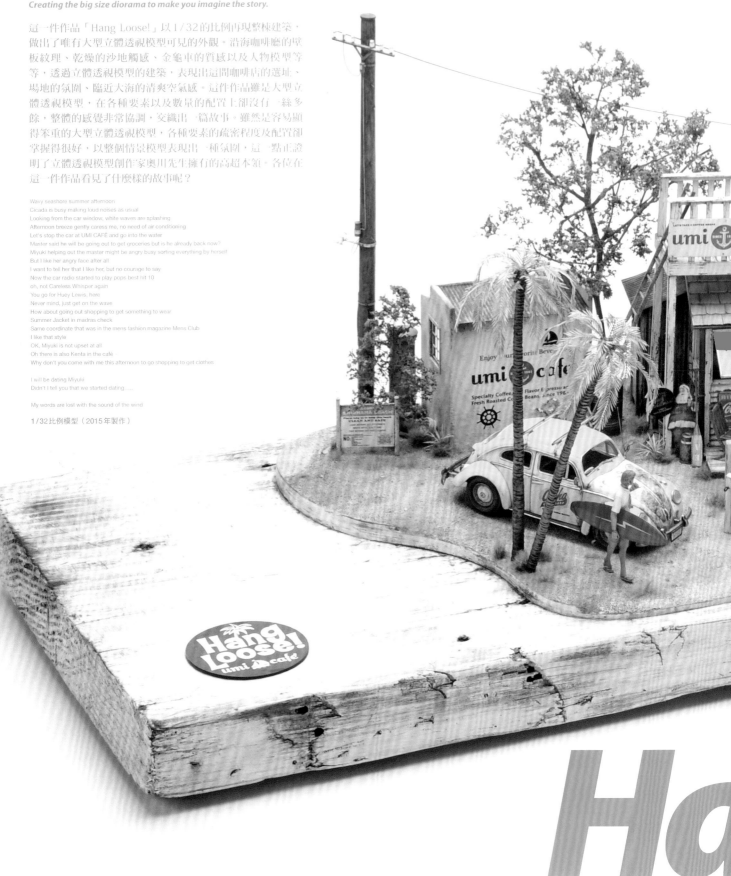

Ha

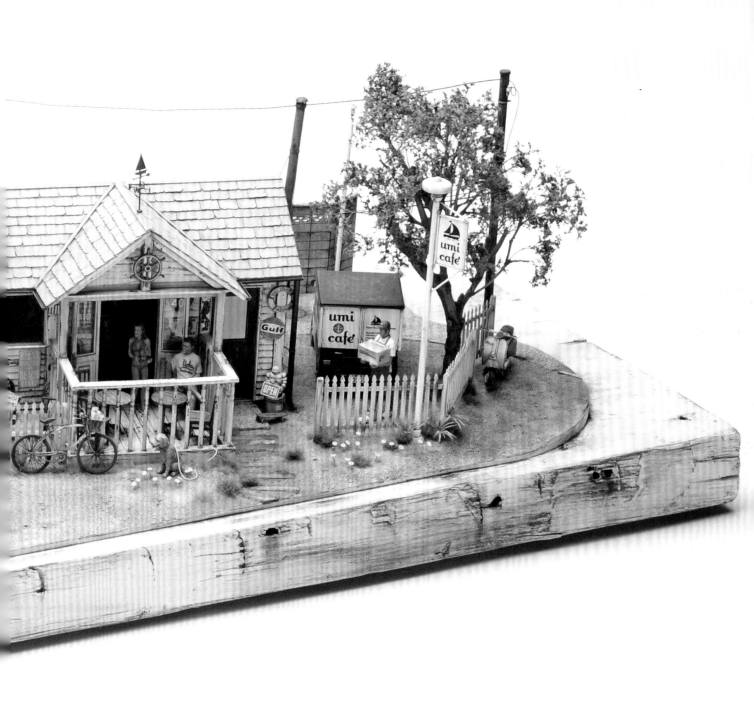

ng Loose!

1/32 Scale 2015 production

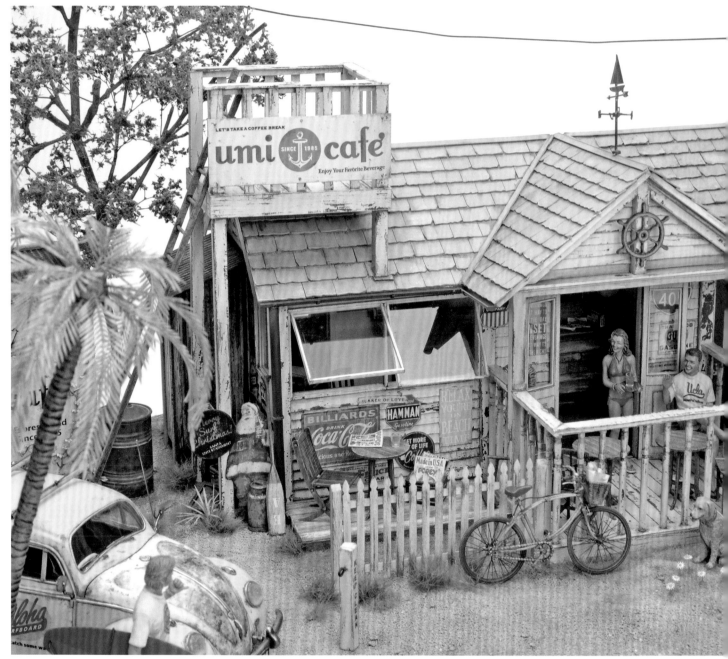

　我之前創作過題材為「一間位於海邊的店家，從這個角度看過去充滿了美式風情，但從另一個角度看過去卻又是日式風情」的作品「Hang Loose!」，此次的作品正是先前製作過的「Hang Loose!」的再製版。第一代的「Hang Loose!」展示在湘南的蔦屋書店附設的汽車用品店 CAR LIFE LAB，客人看見了之後便希望店家可以出售這組模型，不過那件展示的作品已經舊了，而且機會也難得，所以我決定與 CAR LIFE LAB 的老闆合作，重新打造一組「Hang Loose!」，因此有了第二代的「Hang Loose!」。這件「Hang Loose!」的底座大小是根據客戶擺放立體透視模型的位置空間裁切而成，而且這塊底板還是使用舊的鷹架踏板來製作。另外，第一代「Hang Loose!」就收錄在前作《景觀模型的創造與製作 vol.2》，請各位讀者務必瞧瞧。

　原版「Hang Loose!」的中間建築物設定為模型店，這次則按照客戶的意思改成在海邊營業的咖啡店「umi cafe」。「umi cafe」是現實中的咖啡店，也是客人很熟悉的一間店，不過實際的店面當然不是這樣的感覺。製作建築物時，我先使用 Illustrator 繪圖，再請「cobaanii mokei 工房」做雷射切割，然後自己貼上細部的木板。建築物周圍的人物模型的數量及肢體姿勢所呈現的感覺，也都是配合客人的意思來配置。

　停在一旁的「umi cafe」廂型車是有井製作所（現 Micro ace）的 1/32 比例本田 T360 小貨車，安裝了衝浪板車頂架的福斯金龜車則是使用 Airfix 的 1/32 比例的模型組。我想打造出車輛長期在海邊行駛的感覺，所以把這兩輛車都做成了與普通的汽車模型的質感相當不一樣的老舊感。這本書收錄的其他作品大多都是這樣的感覺，這些都是使用模型舊化粉來呈現。像是掛在建築物外牆上的廣告看板上頭的髒污，幾乎都是使用模型舊化粉來表現，因此模型舊化粉是我不可或缺的創作素材。（奧川）

Hang Loose!

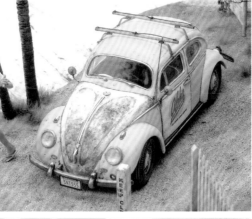

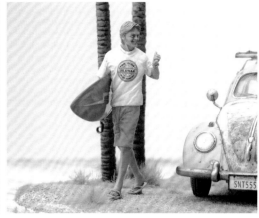

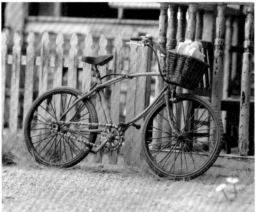

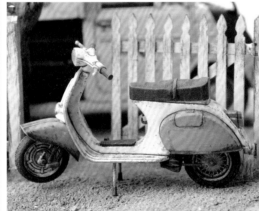

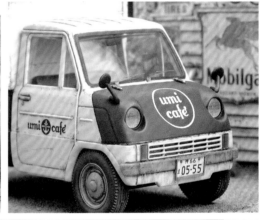

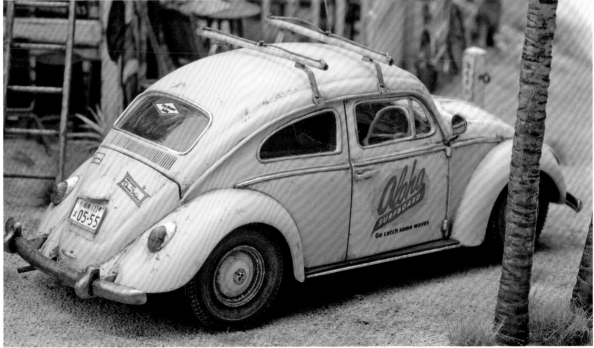

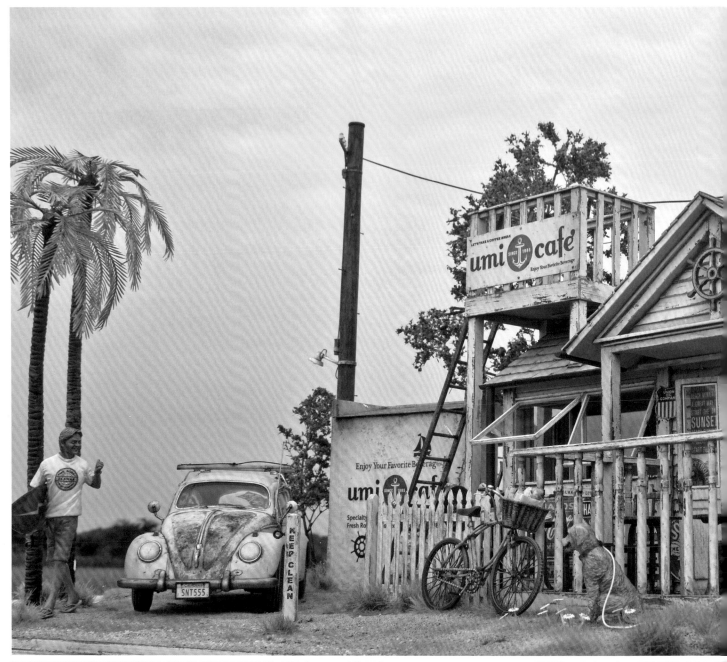

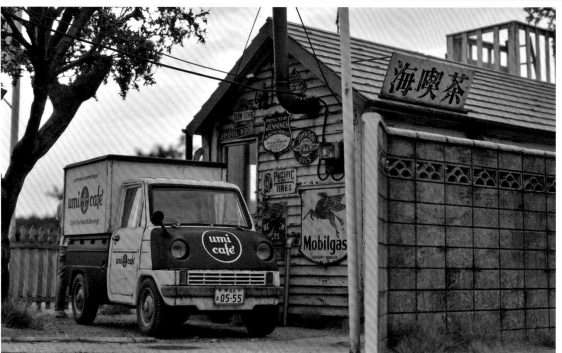

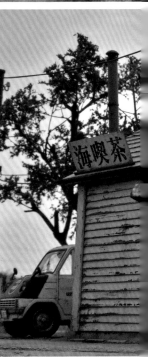

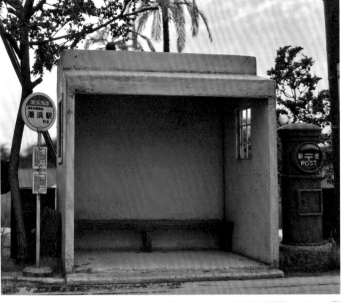

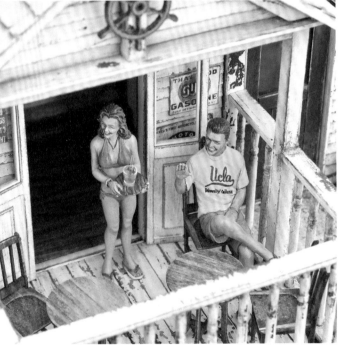

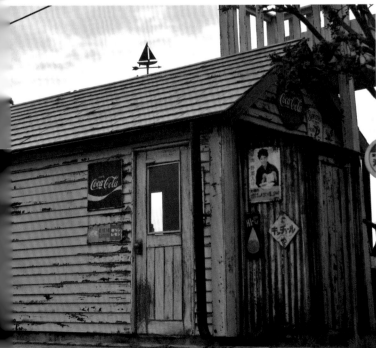

Just to meet the special girl, the terrace is my reserved spot.

This is the second edition of "Hang Loose!" using the same subject. Initial "Hang Loose!" was displayed in CAR LIFE LAB placed inside Tsutaya bookstore in Shonan, but there came a person who wanted to buy that work of art. But since the initial edition was already worn out, it was decided to remake a new one with some customized order and here is the second edition of "Hang Loose!" (you can refer to the first edition in book "Landscape Creation 2" if you want to take a look at that one) It is a masterpiece with the customized order applied especially the base size is as exactly the same size that customer desired to have.

By the way in the original "Hang Loose!" the center building was a modeling shop but in the second edition it turned into cafe named "Umi Cafe" as customer ordered.

This was named after the real existing café where the customer owner used to go, and this is what is special about the order made model.

This diorama element is full of good taste of Okugawa. Delivery van is Honda T360 of ARII 1 : 32.

Volkswagen that has surfboard rack is a scale kit from Airfix 1 : 32, instead of making it into brand new shiny model applied the expression of nice worn out taste.

Also the bicycle used came from Diopark Great Britain military folding bicycle. Set a basket to change it into a normal bicycle.

He has selected some parts to change as if it is the beach cruiser type, where his taste also stands out.

Enamel plated sign outside wall of building are all made of images of mid century US signage printed out on the cardboard plate.

He expressed faded colored texture by rubbing the surface lightly with sanding sponge and finishing by layering brown pigment using acrylic liquid thinner to express the rust.

This work shows all the weathering technique Okugawa owns in many places.

Make the building 製作建築物 1

使用 Illustrator 製圖,再以雷射切割輸出。使用水性透明黏著劑把裁切成細條狀的板子貼在厚紙板上,做成外牆。

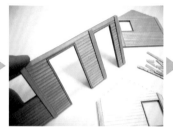

黏貼時讓牆面上方的板子疊在下方的板子之上。

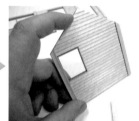

完成一面外牆的狀態。

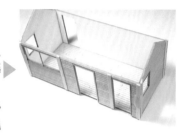

組合起完成的牆面與地板。

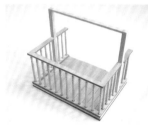

露臺的部分使用 0.5～1mm 的板材與 5mm 的角材組合製作。欄杆扶手的部分使用牙籤。

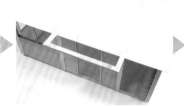

裁切好屋頂的零件,安裝露臺上方的木框。

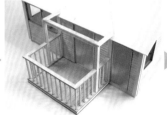

組合露臺與屋頂,確認好位置。

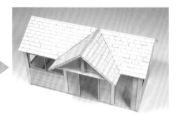

把雷射切割好的薄板貼在屋頂上,重現石板瓦屋頂。

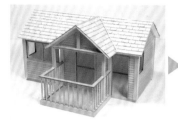

把組裝好的屋頂與露臺裝在建築物的樣子。

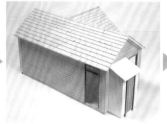

使用 PLASTRUCT 的塑膠浪板搭建出主屋旁的倉庫。

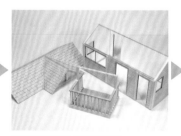

屋頂與露臺還不必與主屋黏接。

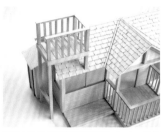

屋頂上的天台同樣使用厚度 0.5～1mm 的板材製作。這部份同樣還不用與主屋黏接。

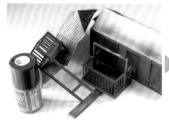

使用 Mr.COLOR 桃花心木色(油性漆)噴漆將屋頂以外的部分上漆。

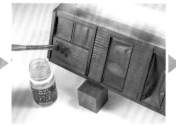

塗上 AK Interactive 的「HEAVY CHIPPNG」掉漆液,打造出風吹雨淋後的牆面油漆剝落狀。

噴上白色的 Primer Z 模型底漆,用來打底兼塗裝。Primer Z 模型底漆的顏色很淡,所以顏色較淡的部分再噴上 Mr.COLOR 的白色油性漆(罐裝噴漆)。

使用沾水的鋼刷、筆刀剝除部分塗料。剛才塗過「HEAVY CHIPPNG」掉漆液,所以可以輕鬆地剝除。

H a n g L

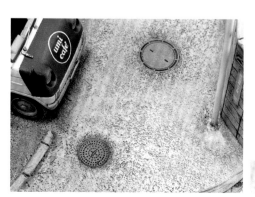

Make the building 製作建築物②

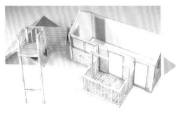

建築物整體的塗料已完成剝落的狀態。

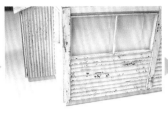

塗料剝落得太誇張的話,看起來就會像廢棄房屋,所以要適可而止。

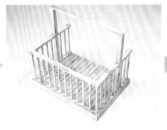

在剝落露臺的塗漆時,要去注意哪些會是鞋子踩踏的地方或是手會觸摸的部分。

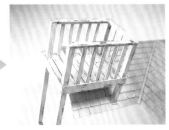

屋頂天臺也是一樣,剝落塗漆時要注意哪些會是觸摸或踩踏的部分。

使用 GSI Creos 的 Mr.Weathering Color 舊化漆(深咖啡色)塗色,表現出雨淋的痕跡。

使用 Mr.Weathering Color 舊化漆的專用稀釋液暈開塗料。注意重力的方向,使用棉花棒由上往下塗抹。

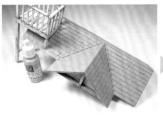

以筆塗的方式將屋頂塗上 Acrylicos Vallejo 的蒼藍色(Pale blue)水性漆。

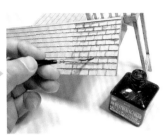

沿著屋瓦的邊緣,用筆塗上深咖啡色的 Mr.Weathering Color 舊化漆。

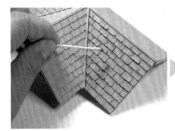

使用棉棒由上往下一邊弄出痕跡,一邊擦拭。

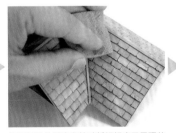

使用粗目的研磨海棉砂紙輕輕磨平屋頂的表面。

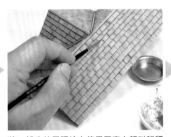

將一部分的屋頂塗上使用壓克力顏料稀釋液調開的模型舊化粉,改變屋頂的色調。

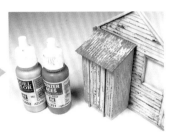

屋側的倉庫分別塗上 Acrylicos Vallejo 的湛藍色(Azure)水性漆與輕鏽色(Light Rust)水性漆。

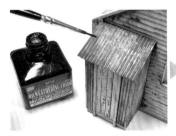

浪板的部分同樣也塗上 Mr.Weathering Color 舊化漆。

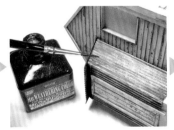

側面也塗上 Mr.Weathering Color 舊化漆。等待舊化漆乾燥時可以將模型橫放,這樣塗漆比較不會往下流。

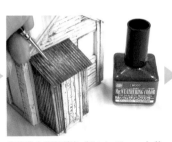

接著塗上紅棕鏽色(Stain Brown)的 Mr.Weathering Color 舊化漆,製造出浪板屋頂的生鏽感。

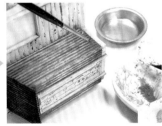

把模型舊化粉加上壓克力塗料稀釋液,塗在倉庫左右兩側的浪板上,表現出鐵皮的部分生鏽。

oose !

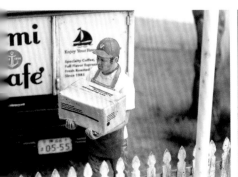

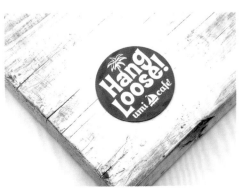

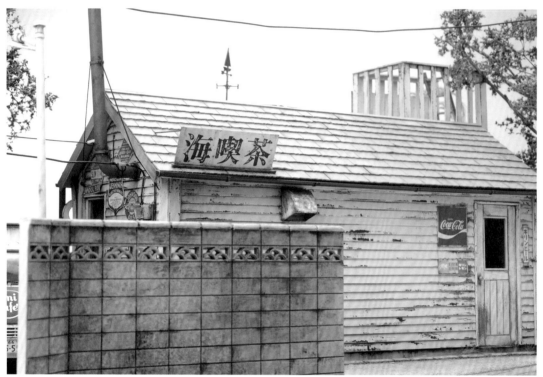

　從不同的角度就能看見截然不同的樣貌，正是「Hang Loose!」的一大看點。從海岸一側望去是美國西岸海灘上的咖啡店，但從相反側的馬路一側來看，則是懷舊日本風景，讓人想起了湘南一帶的景色。可口可樂、BonCurry等懷舊的琺瑯廣告看板、公車站牌、水泥牆邊的木頭路燈以及舊式郵筒等等，滿滿的「昭和時代後期日本風情」元素傳達出作品的時代設定及氛圍。換句話說，讓這件立體透視模型透露了整體故事劇情的部分，正是這件作品背面的風景。

　外牆上的琺瑯廣告看板或是寫著「海喫茶」的店名看板等等，都是使用厚紙板列印而成。公車站也是使用列印的圖片加上塑膠材料製作而成。馬路旁的石牆則是使用在「cobaanii mokei工房」雷射切割而成的MDF密集板（以木材碎片加上黏合劑固定的成形板），並使用油性塗料稀釋液稀釋膏狀模型補土，然後塗在密集板上，做出帶著混凝土的質感。

　為了表現出與砂地截然不同的柏油路質感，使用油畫刀均勻地塗抹上美術材質素材的粗浮石凝膠（參考P5）。待粗浮石凝膠硬化之後，再以粗研磨海綿砂紙大力研磨，將表面的粗糙顆粒磨平，達到一定程度的平滑度，做出接近柏油路的感覺。

　公車亭先以珍珠板組合而成，然後再製作外牆，將表面塗上TAMIYA的立體情景模型塗料，再以筆塗的方式塗上以油性塗料稀釋液稀釋的膏狀模型補土，以及液狀模型補土，表現出混凝土製的建築物的粗糙表面。郵筒使用的是有井製作所（現Micro ace）的「昭和歲時記系列」，與公車亭一樣都是塗上稀釋後的膏狀模型補土，打造出凹凸不平的質感。豎立在一旁的木頭電線桿則是以真正的木棍加工而成。電線桿上左右兩側的腳踏釘使用大頭針製作，而電線連接的橫擔部分，則是直接使用1/35比例電線桿模型組的零件。

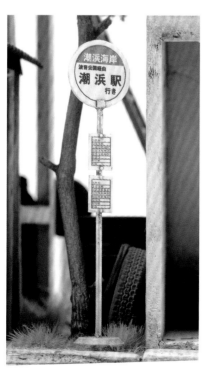

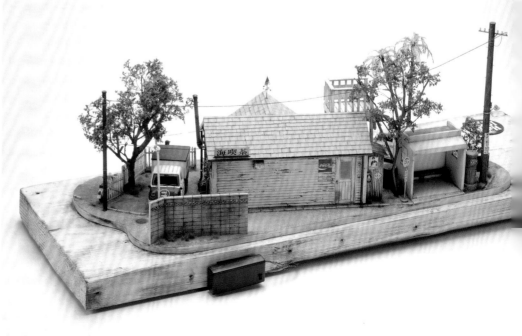

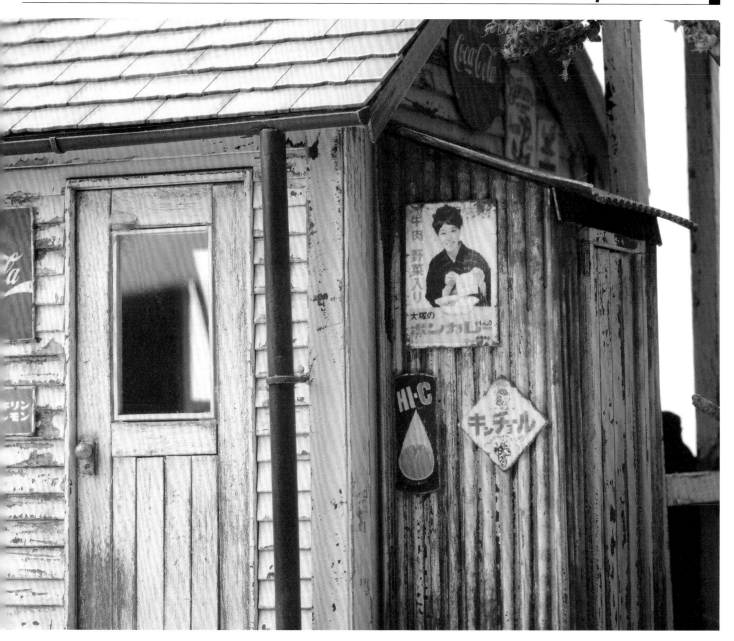

Rusted roof panels and walls are a few of the appealing points of "umicafe".

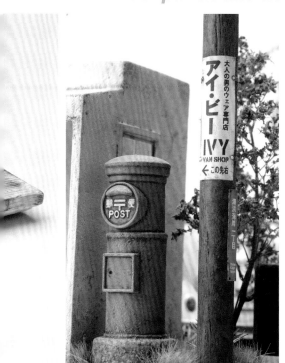

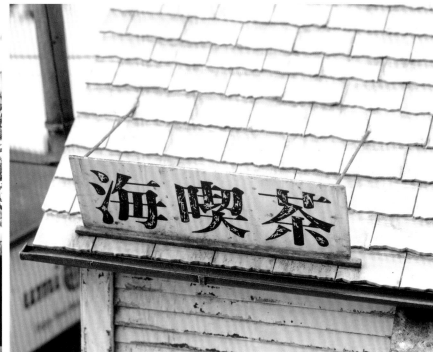

Make the ground & building 製作建築物與地面

屋頂同樣塗上使用了加入了壓克力塗料稀釋液的模型舊化粉，做出屋頂表面粗糙不平的質感。

完成了建物整體的舊化作業。

木地板還不用安裝在建築物內，要另外上顏料。木地板的縫隙以雷射加工而成。

木地板全部塗上褐色（Ground Brown）與紅棕鏽色（Stain Brown）的Mr.Weathering Color舊化漆。

使用塑膠材料製作屋簷集水槽、煙囪、排氣口等。

電表的蓋子也塗上模型舊化粉。

排氣口的蓋子使用褐色系的模型舊化粉表現出鐵鏽。

屋簷集水槽用幻影灰色Primor Z模型底漆、大煙囪用中性灰色Acrylicos Vallejo水性漆、小煙囪用銀色Mr.COLOR壓克力塗料。

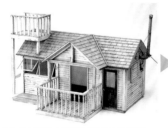

煙囪和屋簷集水槽配件等安裝好的狀態。

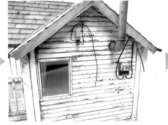

外牆上的配線最後要連到電線桿。

使用超精細噴墨用影印紙（厚質）印刷出加工好的圖像，製作廣告看板或室內的雜誌等。

印刷並裁切好的廣告看板類。

使用雷射切割的木板或珍珠板製作櫃台以及室內的門片。

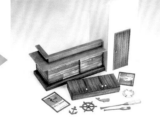

使用Mr.Weathering Color舊化漆塗裝櫃台、門片以及日常用品。

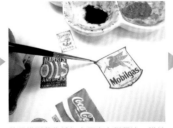

使用模型舊化粉加上壓克力稀釋液，描繪出外牆招牌的鏽痕。

完成的廣告看板。使用研磨海棉砂紙輕輕磨擦表面，也能呈現出褪色的樣子。

H a n g L

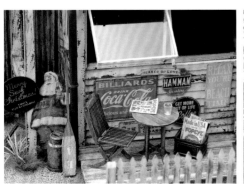

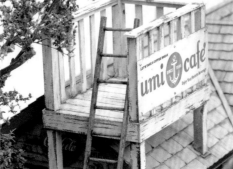

Make the ground & building 製作建築物與地面

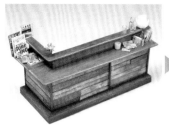

把雜誌等物品擺在櫃台上。

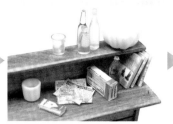

瓶瓶罐罐則是借用了 AVF 模型用的裝飾品。

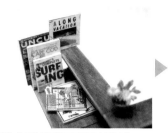

雜誌或唱片都是使用厚紙板印刷而成。

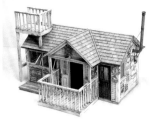

把舊化處理過的廣告看板黏在外牆上。

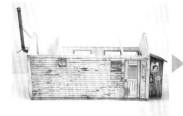

模型背面的外牆要做成日本風情的景色，所以選擇了帶有日本風情的廣告看板來裝設。

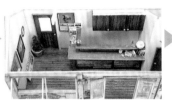

櫃台、上方的壁櫃等等室內配件也要安裝起來。

使用珍珠板組裝公車亭。窗框使用雷射切割而成的木板。

使用沙漠黃沙色（Light Sand）的TAMIYA 情景特效塗料，打造出沙地粗糙的質感。

以筆塗的方式塗上稀釋後膏狀模型補土，以及液狀模型補土，讓表面的凹凸感更加明顯。

有井製作所的「昭和歲時記系列」附屬的郵筒同樣也使用筆塗的方式塗上液狀模型補土，讓郵筒表面呈現凹凸不平的感覺。

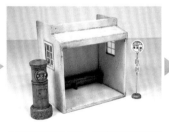

公車站牌附近的建物。公車站牌使用印刷後的厚紙板以及塑膠材料製作。

接下來要製作底板。首先貼上裁切成不規則形狀的木板，做出大片地面。

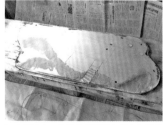

把底板塗白，然後使用紙黏土將木板的落差填平。

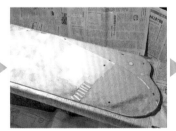

地面塗上粗浮石凝膠，做出砂地。

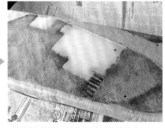

地面塗上柏油，區分出砂地與柏油路。

使用白膠將 MORIN 的草地製作素材「Glass Selection」（淺綠草皮）種植在部分地面上。

o o s e !

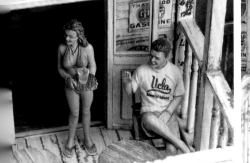

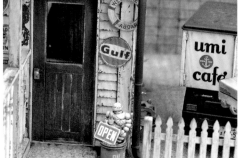

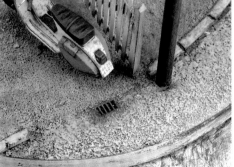

Make the vehicle 製作汽車

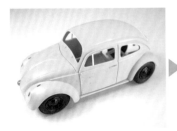

福特金龜車（Airfix 1/32比例模型）。安裝車內配件之前，暫時將底盤與輪胎組裝在一起。

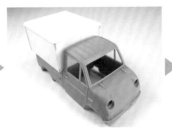

將本田T360（有井製作所〔現Micro Ace〕出品）小貨車加上用膠板做成的車廂。

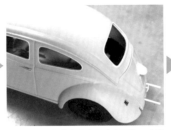

以細膠條自製車窗的密封防水膠條，車牌燈的擋板也使用膠板自製。

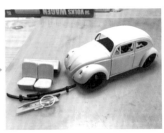

儀表板、座椅、保險桿另外組裝。

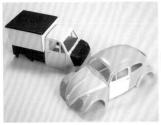

白色塗裝為消光白色Mr.Color油性漆，車身的咖啡色部分則使用艦底紅色油性漆塗裝，黃色部分為亮光黃色Mr.Color油性漆。

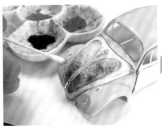

使用壓克力塗料稀釋液調開咖啡色的模型舊化粉，然後塗裝汽車引擎蓋，表現出引擎蓋生鏽的痕跡，再使用棉花棒刷掉塗料。

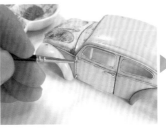

車門等縫隙部分同樣塗上咖啡色的模型舊化粉，形成鏽痕。

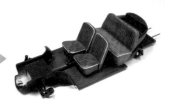

將汽車內部進行舊化處理，與車殼一樣使用咖啡色的模型舊化粉。

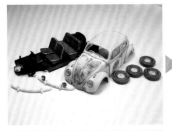

一口氣將全部的零件組裝完畢並不利於塗裝作業，因此保險桿、鋁圈等零件都是各自組裝，並先經過舊化處理。

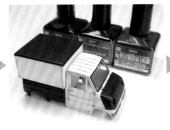

T360車身的汙損程度不必太嚴重，才能讓模型有變化性。先沿著車殼的刻線，塗上GSI creos的Mr.Weathering Color舊化漆。

接著將車門邊框等顏色較深的部位輕輕塗上模型舊化粉。

腳踏車使用DIOPARK的「WWⅡ Brisishi Military Bicycle」。依照說明書組裝，並裝上蝕刻片。

速克達摩托車也是直接使用DIOPARK的「Italian Civilian Motorcycle」。

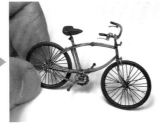

腳踏車的車身噴上珊瑚藍色（Coral Blue）的TAMIYA水性漆，輪胎則塗上消光黑色（Flat Black）的Acrylicos Vallejo水性漆。以咖啡色系的模型舊化粉進行舊化處理。

將整台速克達摩托車塗上消光白色（Flat White）的Mr.Color油性漆，再將輪胎擋泥板單獨塗上蒼藍色（Azure）的Acrylicos Vallejo水性漆，最後使用咖啡色系的模型舊化粉，製造出整台摩托車的汙痕。

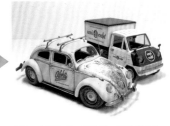

安裝好車體內部、保險桿、輪胎等零件，完成了金龜車與T360小貨卡。

H a n g L

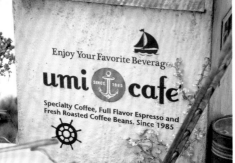

Make the Electric spectaculars & Figure 製作燈飾及人偶

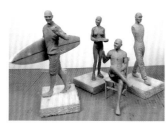

人偶的材料為 Sculpey 黏土。先將骨架加上肌肉，在還沒穿上衣服的狀態下確認好人物的姿勢。

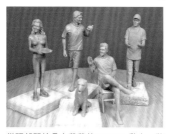

從頭部開始疊上薄薄的 Sculpey 黏土，做出皮膚皺紋等細節。這些人偶出自於岩坂浩司先生之手。

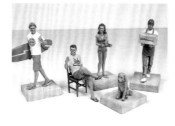

Sculpey 黏土硬化之後，全部塗上 Delta Ceramcoat 彩繪顏料（彩繪藝術用的壓克力顏料）。

女店員手上的托盤以及玻璃杯，都是以膠板或是樹脂軟管自製而成。店長（照片右下）的紙箱也是自製的。

把圓木棒的其中一端削斜，以 ITALERI 的電線桿模型組、膠板、大頭針等材料製作電線桿的細節部分。

小電線桿一樣使用圓木棒與膠材製作。電線桿頂端的蓋子使用人物模型的配飾零件。

掛著「umi cafe」招牌的桿子同樣以膠管製作，並將電燈用的配線穿過管子內部。

配線用的引線先穿出桿子再穿過底座，接上電源。

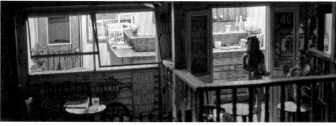

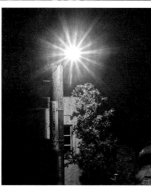

　這件「Hang Loose!」模型不只是兩盞路燈裝上燈泡，就連室內也裝了 LED 燈泡，而固定在底板後方的電池盒（3 號電池×2）則為這些燈飾的電力來源。燈飾使用暖白光的 LED 燈片，屋外的路燈則使用膠管製作燈桿，並將導線穿過膠管進行配線。

　屋內的電燈裝在天花板中間的屋樑上，並將電線固定在屋樑的側面，再沿著內牆延伸到底座下方，就能讓電線變得不顯眼。室內電燈的燈罩使用布鈕扣製作組（衣服鈕扣 DIY 材料包），直接將其中的笠狀金屬配件黏在屋樑上。建築物的內部一共配置了兩片 LED 燈片。

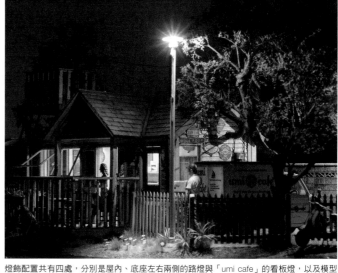

燈飾配置共有四處，分別是屋內、底座左右兩側的路燈與「umi cafe」的看板燈，以及模型背面的石牆旁的燈桿。這些燈飾的位置配置照亮了整塊模型的底板，同時也讓人感覺到立體透視模型的空間向前方延伸出去。

o o s e !

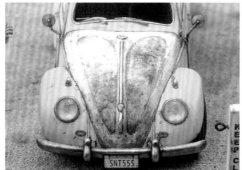

Chapter 2

製作洋溢著生活感的
「工作車」小型立體透視模型

Creating the "Working car" vignette with full of lived in feel.

雖說奧川先生現在的作品都是以海外風景為題材，但對於奧川先生而言，製作模型的原點並不是模型的打磨拋光處理，反而是製作展現出生活感及溫暖的汽車模型。奧川先生之前原本是一位AVF模型製作者，1998年開始運用AVF模型的製作技巧創作富有生活感的皮卡車（Pickup Truck）模型。自那時起，奧川先生便在以世紀中期現代風格的美國、歐洲或湘南的海灘等風景為題材的模型製作「打開新視界」，至今仍持續創作這一類型的作品。因此，本章將介紹最接近奧川先生創作原點的汽車模型，這三件作品就連本人也表示是「因為有興趣才製作的」。汽車的座椅上、車斗上都是散亂的物品及貨物，車身還帶著生鏽的痕跡，就算沒有人物出場，作品本身也能滔滔不絕地道出這輛車的主人及其職業，甚至是個人興趣，以及所處年代等資訊。不論哪一件作品，都堪稱是大師級的手藝。

Currently Okugawa creates works that has landscapes with refreshing theme, such as California, Hawaii, or areas in Pacific Coast area, or rural café or bar in Europe or beaches in Shonan or Chigasaki in Japan. But what he has as a starting point is expressing car model which has rust in some places,has little dirt with realism and everyday life. It was 1998 when he intentionally created works like that, back in the old days 18 years ago from now.
At that time Okugawa used to model military tanks and US military cars known as AFV models.
But as he created the old pick up truck as piece of work using AFV modeling knowledge and technique in the magazine, there was a big reaction.
It was collion that car modeling used gloss painting, so what he did to express the everyday life with warm texture gave a new impression to the readers.
It was same with Okugawa that after this piece of work, he started creating the same taste of work until now, such as mid century good old days of US, European car or building,also Japanese places such as Shonan beach back in 1980s. And he even made garage kits out of structure created for these works,started selling as his own brand, where his talent has spread in many directions. Nowadays he creates these piece of works by order given from his great fans,but the start point of these piece of work full of entertainment are those car models with everyday life taste.
These 3 pick up truck piece of work introduced here are created in different year and situations.
But they are all masterpiece that made Okugawa say he created as his own pleasure, each vehicle has its own story and even image of the vehicle owner is visible.
Car seats with many things scattered and unorganized cargo tells you the story behind this vehicle and allows one to imagine many things.
These pick up trucks can be the symbolic subject showing the start point of all Okugawa's work.

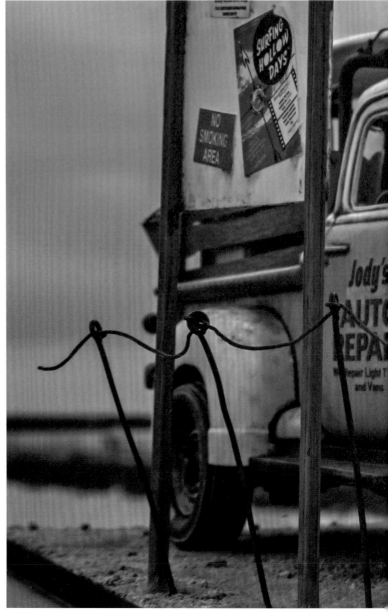

本書一開頭便提過，我原本就非常喜歡汽車。車身的外型當然也是原因之一，不過車輛本身就是一種很好表現出懷舊情感的要素，所以適合當作情景創作的題材，這也是為何我如此喜歡汽車。而且，車身外殼通常都會印製公司行號等文字，當作創作素材時也非常引人注目。因此，我創作的汽車模型通常都是某間店家的營業用車，也就是所謂的「工作車」。

這裡介紹的三個作品都是出自於我個人的喜好。我在創作每一件作品時都放進了自己喜歡的元素，就這樣完成了模型創作。車斗上要放哪些物品也是自己規劃的，實際上並沒有這樣的一台車，不過像這種國外的老舊商用車以及周圍的片段風景，都是我非常喜歡的主題。這樣說來，也許這些正是最能反映出我個人興趣的作品。（奧川）

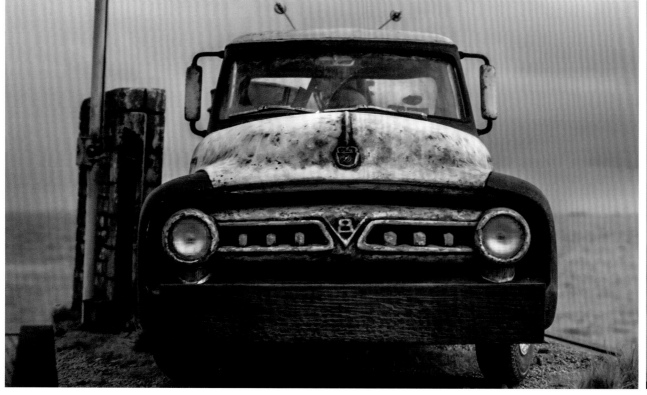

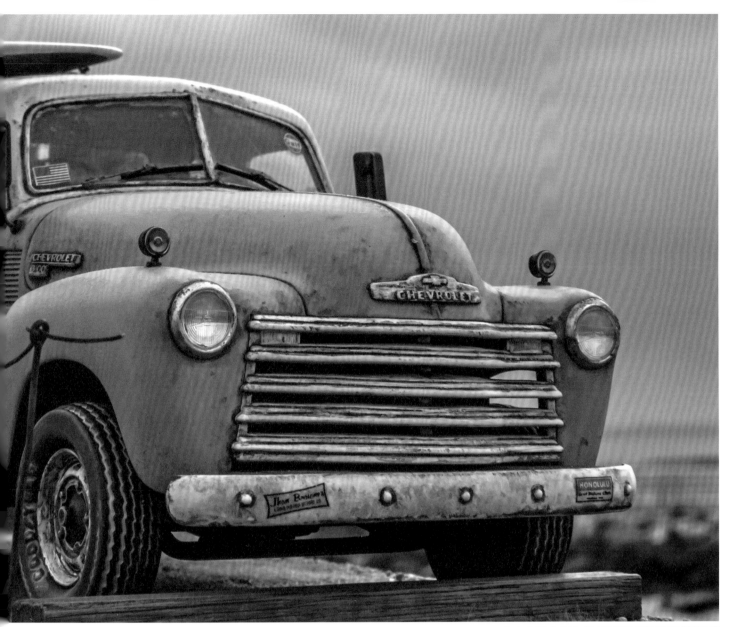

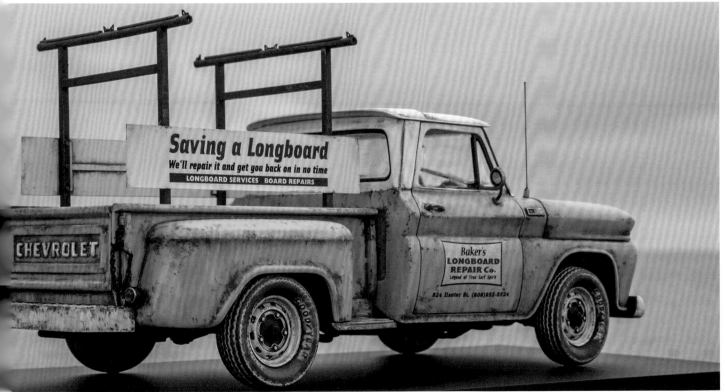

Jody's Auto Repair

1/24比例模型（2012年製作）

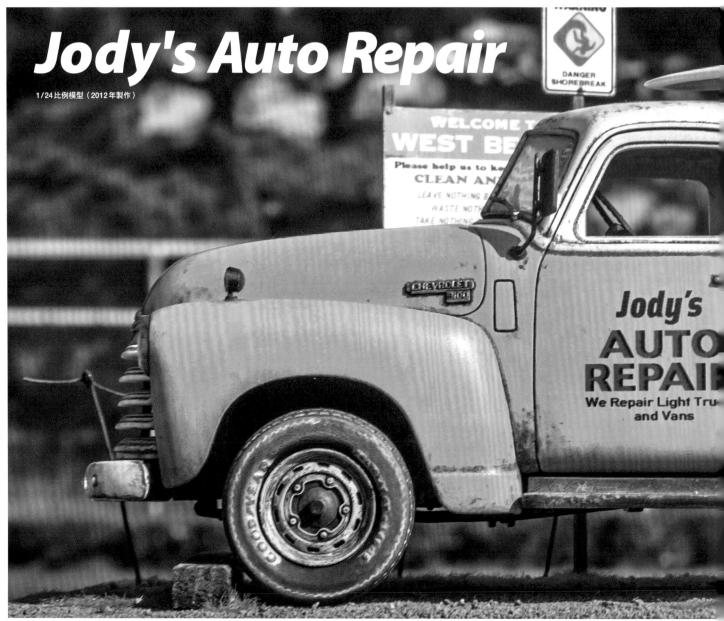

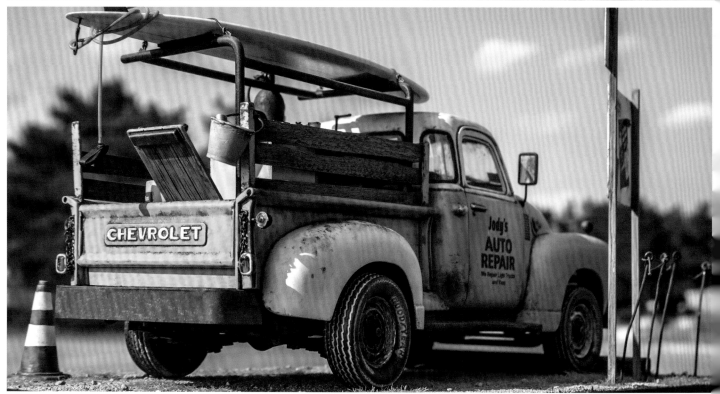

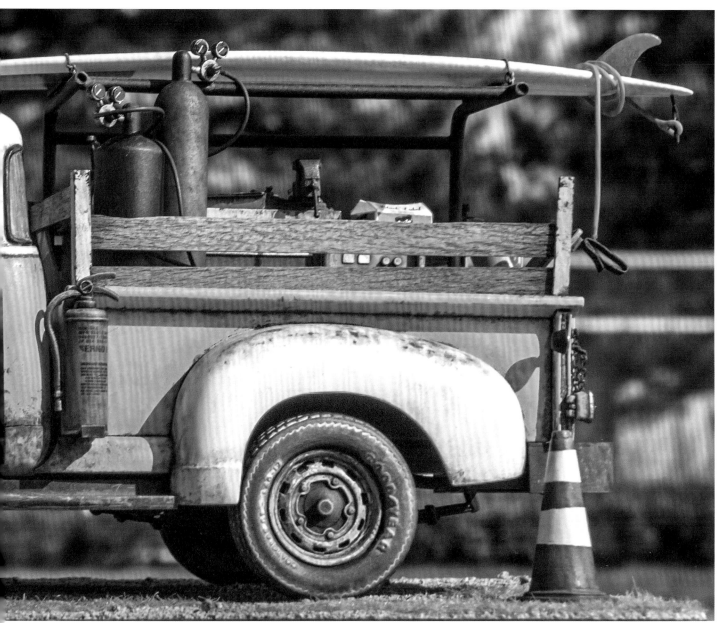

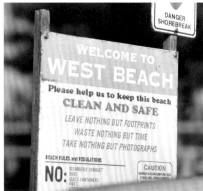

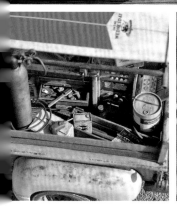

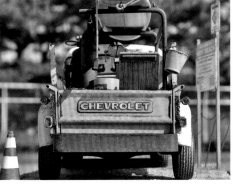

Not just this work but the others works introduced in the pages after this, what Okugawa thinks before starting to create the pick up truck work, is "what he wants to load on to this cargo of this vehicle". He always imagine what he wants to load on the cargo or the seat, then count backwards to decide what car type or situation it will be.

Rarely there is a work starting from " I want to make this car model" but at least the work using pick up truck has strong motivation in creating what should be on that cargo.

This work of Chevolet 3100 pick up truck is made from those inspiration too. What Okugawa wanted to load on to the cargo were DIY tools.

so the subject he selected this time was small bicycle repair shop pick up truck. Situation describes that the repairer is a surfer who stops by and went to sea

during working time. Chevolet truck kit has no alteration but used as it is.

Some changes made to the wooden fence at both sides of cargo, using Vallejo color painting to paint real wooden fence.

The surfboard on the rack of cargo was recreated by moldings the original shape from balsa wood, then refined using resin.

All drawings on the surfboard are made of handmade decal, and finished by adding a slight weathering taste.

The tools on the cargo, which is the most important factor of this work, are made by parts for car models Fujimi 1 : 24.

Fujimi sells kits such as pit crews or garages, tool and tool boxes, locker and tyre racks,all used to decorate Okugawa's 1 :24 scale works. From those stocks he selects tool box, some small tools carefully placed on the cargo as though they are scattered unintentionally.

This placement is very difficult since the balance between them will not be natural if not done carefully. Okugawa has superb taste for doing so.

Another characteristic of his car model works is seen on scattered maps and magazines paying extra attention to place on the seats.

Cardboard boxes on the seat are from the US garage manufacturer paper kit.

Also the magazine "Playboy" on the seat is made from images from internet printed out and sealed.

Map, "U.S.A Today" is also printed out to be recreated.

Orange colored bottle (which Okugawa says looks like Gatorade) is made out from bottle from AFV model 1 :35.

Also to express the patching finishing of the seat, he actually used Gingham check cloth and cut in pieces to stick them.

For the vehicle body painting, he used both lacquer spray can paint and Vallejo brush painting.

After the paints are dried, he draws the rust all around, using brown pigment using acrylic liquid thinner with brushes.

Pigment has characteristic that its particles are rough, even after using the thinner it tends to get matte after applying this material is used often to express Okugawa's works.

These are used not only to express to paint vehicle but building raindrop stains and rusts start growing down from metal parts, which are all indispensable to Okugawa's work.

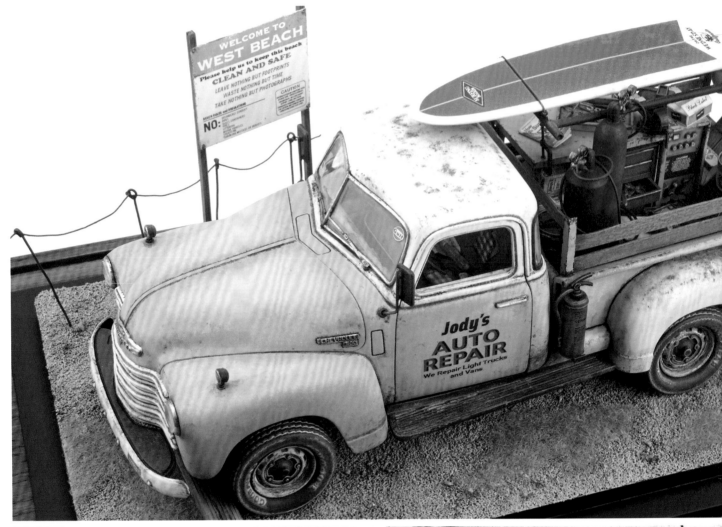

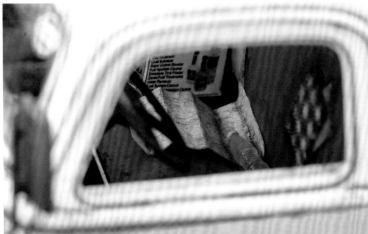

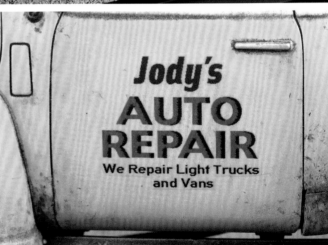

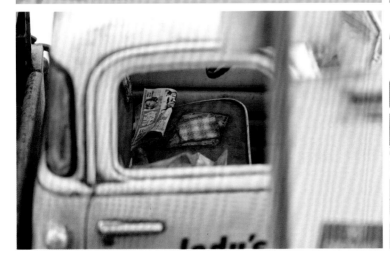

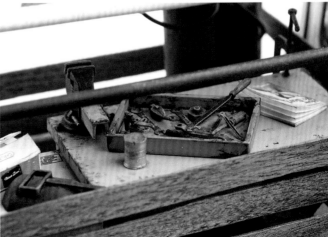

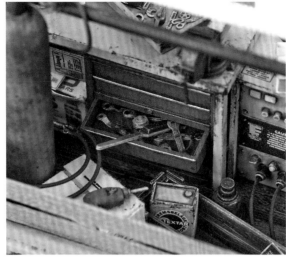

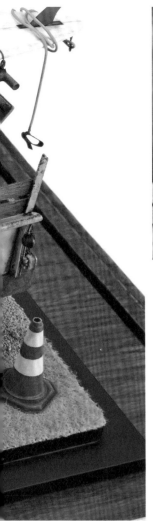

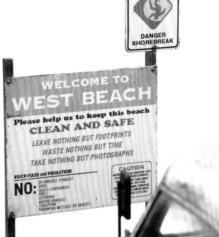

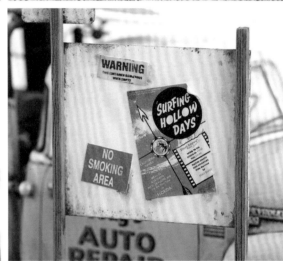

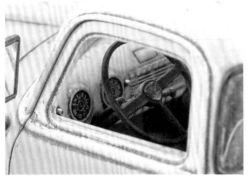

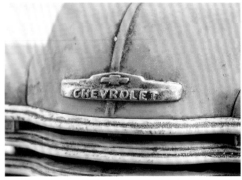

　奧川先生在進行皮卡車的創作時，首先考慮的是「貨車的車斗要放哪些物品」。特別是在製作汽車模型時，都是先想好車斗或是座椅上面放置的物品，再回頭考慮車種或是情景設定。雖說奧川先生的作品當中還是有因為「想以這款車進行創作」而製作的模型，但至少在以皮卡車為題材的作品之中，思考貨車要放置哪些物品，是奧川先生創作的強烈動機，也是促使他進行模型創作的動力。這輛Chevrolet 3100皮卡車也是奧川先生先從車斗得到靈感，進而創作的作品之一。在這件皮卡車的作品當中，奧川先生想在車斗上放置的物品就是「工具」，於是他決定以小型汽修廠的營業用皮卡車作為創作題材。在頗有氣氛的情景之中，融入了喜歡衝浪的汽修工在工作之餘忍不住繞到海邊的情境。Chevrolet貨車的車體直接使用AMT 1/25比例模型組，沒有額外改造。車斗左右兩側的木頭柵欄以真正的木板塗裝Acrylicos Vallejo水性漆，僅僅稍微加工。

　安裝在車斗上方貨架的衝浪板，製作時先以輕木板削出形狀，再進行樹脂翻模。然後將複製成的衝浪板加上圖案標誌等細節，並稍微進行舊化處理，製作出真正衝浪板的質感。

　若說放在車斗上的工具才是本件作品的主題，可是一點也不為過。這些工具全部使用FUJIMI模型公司的1/24比例汽車模型專用零件。FUJIMI模型公司推出各種模型配件的零件組，例如：「Pit crew」A、B套組、「Tool」、「Garage & Tool set」等等，每一款都是奧川先生在製作1/24比例的模型作品時不可或缺的材料。奧川先生從庫存的零件組當中挑選出工具箱或是小型工具，然後仔細地分配這些小零件的位

置，一邊注意零件的密集程度，一邊讓它們自然地分散在車斗上。其實這項分配作業非常不容易，一個閃神就會破壞彼此之間的協調感。能如此巧妙而自然地完成這項配置，大概只有靠著奧川先生對於創作的美感才辦得到吧。

　奧川先生在製作過程中也留意到了座椅上散亂的地圖或雜誌等等，這份細心是他在製作汽車模型時的特徵。倒在座椅上的瓦楞紙箱直接使用美國Garage製造商所的紙製模型組。地圖或「U.S.A Today」報紙則是直接貼上用彩色印表機列印的圖片。橘色的水瓶（奧川先生說：「看起來很像Gatorade運動飲料！」）是1/35比例的AVF模型專用水瓶。而且為了重現座椅表面的補丁，奧川先生還把真正的格子花紋手帕剪成小塊再貼在座椅上。

　車體的黃色部分先使用GSI creos的黃橙色（orange yellow）Mr.Color噴罐，再用畫筆塗上消光黃色（Flat yellow）的Acrylicos Vallejo水性漆；白色部分則另外使用消光白色（Flat White）的Mr.Color噴罐。噴漆風乾以後，再畫出整台車殼的鏽痕，這時使用咖啡色系的模型舊化粉加上壓克力塗料稀釋液，以畫筆或輕或重地塗出鐵鏽。將模型舊化粉當成塗料使用時，表面會形成顏粗的顆粒，因此就算用了稀釋液進行稀釋，塗裝在模型之後也會變成完全消光的狀態，這一點是將模型舊化粉當成塗料使用時的特徵。模型舊化粉是奧川先生常用的材料，除了像這樣塗裝車殼，也可以用來重現建築物的雨水痕跡或是從金屬部分流下的鐵鏽等等，可說是奧川作品當中不可或缺的存在。∎

Jody's Auto Repair

Ralph's Service Shop

1/24比例模型（2011 年製作）

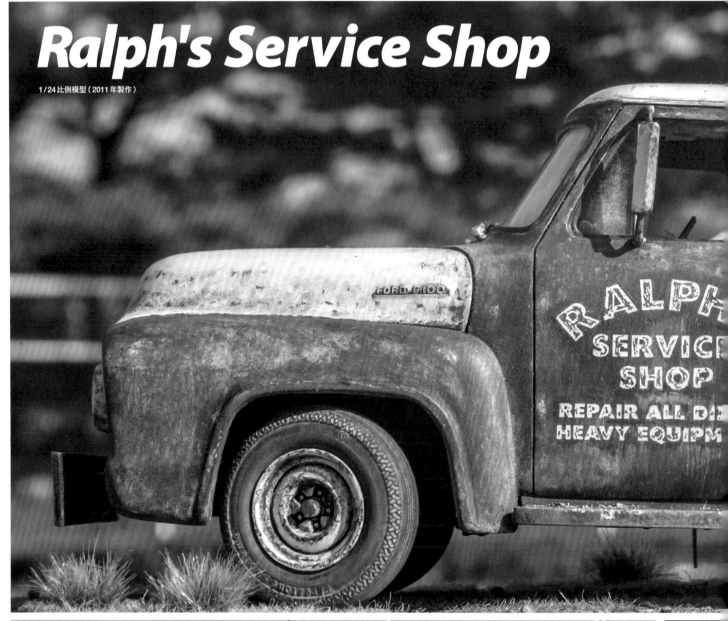

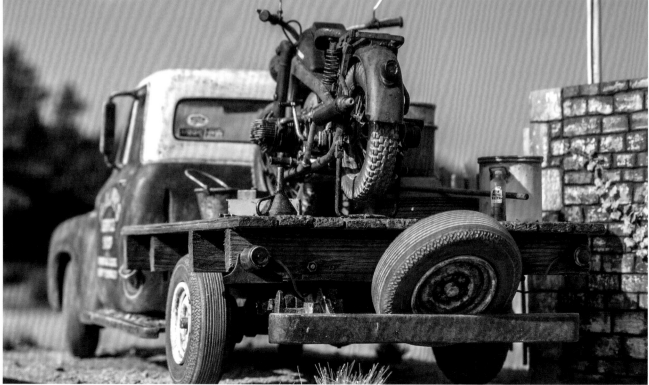

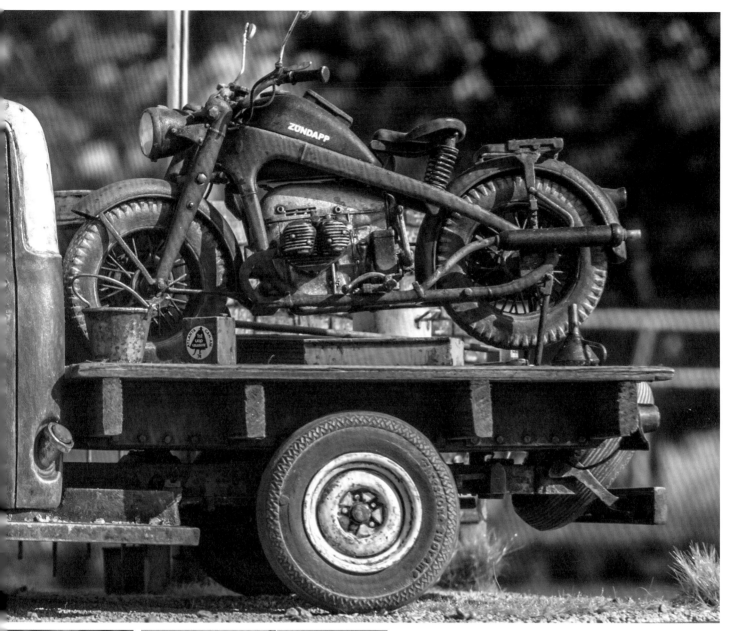

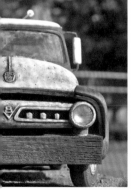
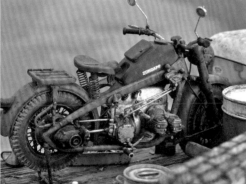

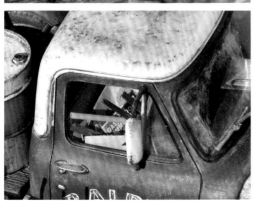

This is work that has great impact showing motor bike on a flat wooden board cargo.

The pick up truck used is Ford F-100 1953 year model, using AMT 1:25 kit. Motor bike on the cargo is Taska KS750 from Zündapp 1:24.

This is fairly new kit and has many delicate details. Okugawa says this situation is "Motor bike was broken on the day before the race, and this truck has come to repair.

it started repairing the bike on the cargo". Has relaxed impression but actually the situation is in haste.

It is also noted that this scene is not just completed by expressing using truck only, but adding brick wall and ground to widening the scene.

He has taken away the cargo part and recreated cargo himself. He used real thin wooden board thinly sliced and sticked together to express the cargo.

Also he rearranged the bumper part using wood material. These wooden parts are all painted using browny Vallejo color. To show the used expression sanding sponge is used for green parts to round the edge.

Other than the cargo and bumper parts, the vehicle kit is used as the original one. The Taska Zündapp is created mostly as original model without changes.

Only changes are the back mirror added afterward on top of handlebar. Chipping taste has been added to show the well used situation.

KS750 was originally German military motor bike, but it can be seen as public use if it is repainted properly.

To show the weathering for the motor bike and truck parts, several browny pigments are applied several times using acrylic liquid thinner.

Pigments are place by tipping at the point of the brushes, then scrubbing them with cotton buds after drying, continue the process until the conditions are good.

The tips are that to express the density for all the colors by weathering where the dirt and rain water are gathered and accumulated, near roof part and green yielded bonnet hood.

Basic color for the vehicle body paints are done by two colors for spray can paint and Vallejo brushed paint. Characteristic of Okugawa's painting method is to use laquer paint and use can spray and acrylic paint such as Vallejo using brushes.

Reason for doing this "Spraying is easy to use, and finish will be flat, on the other hand acrylic has matte finish which brush painting does not bother much"

Basically weather will be applied using pigments that the vehicle body painting method does not really matter.

Tools instruments on the cargo are made from Fujimi kits. Other large parts are used, from front to backwards, Doozy Modelworks 1:24 drum can, junk parts tyre is recreated by resin.

White can is used from AFV accessories of Verlinden, deck brush comes from garage manufacturer in US of 1:24 scale models.

Okugawa says "these loads are placed in random order" but the taste he has is wonderful.

Inside the vehicle he placed the magazine printed out and created by the image searched from internet.

Even there is no one in this piece of work, you can even guess what taste this car driver has from the expression.

Brick wall next to where the truck is parked, this is created using plaster board craved the surface and shaped into bricks and painted in acrylic colors.

Ivy which covers the surface is made of paper painted and bonded.

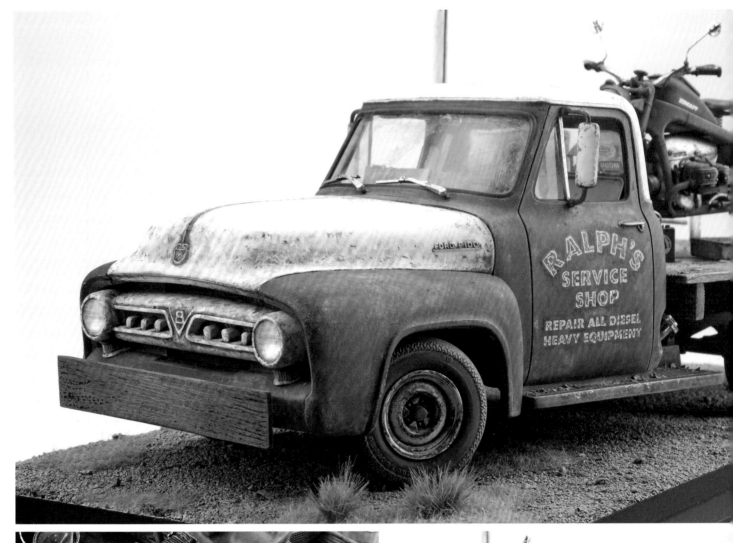

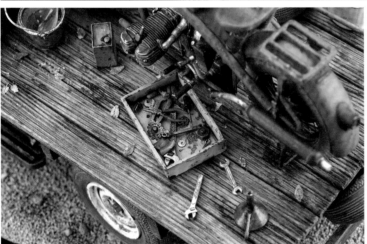

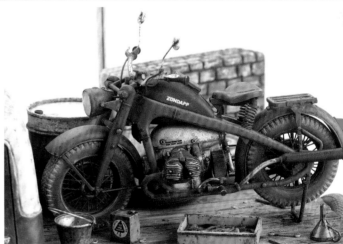

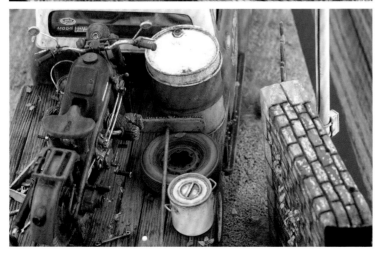

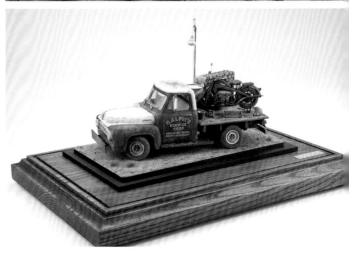

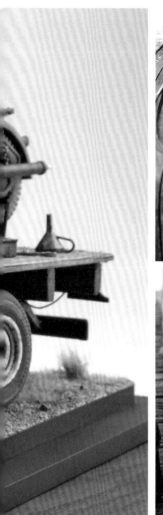

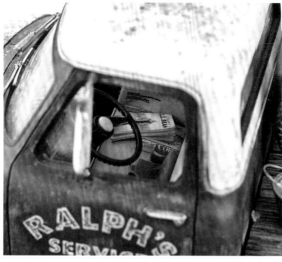

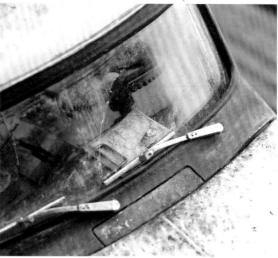

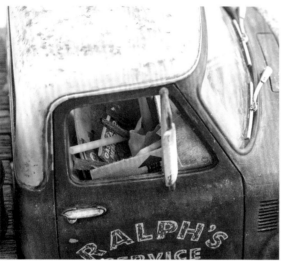

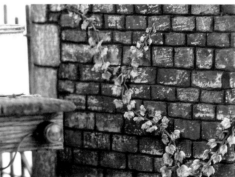

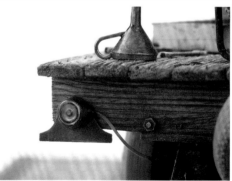

　一台摩托車直接停在平坦的木板貨斗上，是一件頗具衝擊力的作品。這台貨車是福特汽車1953年款的F-100皮卡車，以AMT 1/25比例的模型組製作而成。車斗上的摩托車則是Tasca 1/24比例的Zündapp KS750摩托車。這也是一款比較新的模型組，非常精密。KS750原本是德國的軍用摩托車，但在這件作品當中大幅改變車身顏色，成為民用摩托車。奧川先生表示，這件作品的情境是「摩托車在比賽前一天故障，因此汽修廠的貨車前去維修。而且，就在貨車抵達汽修廠後，便直接在車斗上進行維修」。氣氛看起來相當悠閒，實際上卻是出乎意料地手忙腳亂。

　這件作品的情景同樣不只有貨車，還放進了磚牆與地面的元素，才創作出這件情景遼闊的作品，值得我們多加關注。

　這輛貨車捨去了模型組當中的車斗，再以木材自製。自製車斗使用真正的薄木板，將木板裁切以後再組裝成車斗的形狀。除此之外，也使用木材重現了保險桿的部分。這些木製的部分善用了木頭樸素的顏色，並以TAMIYA墨線液等塗料進行舊化處理。為了突顯出長年使用的質感，邊緣部分用研磨海綿砂紙輕輕磨出弧度。車斗和保險桿之外的車體部分，同樣直接按照模型組的說明進行組裝。另外，停在車斗的Tasca Zündapp KS750摩托車也幾乎是按照原本的模型組進行組裝。方向盤上的後視鏡和圍巾是後來才追加的。這輛摩托車還加上了一些黑色的碎屑，表現出整台車使用已久的氛圍。

　摩托車與貨車的各個部分在進行舊化處理時，分別使用加上壓克力塗料稀釋液的各種咖啡色系模型舊化粉。舊化處理時先以畫筆點上模型舊化粉，風乾後再使用棉棒擦拭，反覆調整直到模型舊化粉的顏色不是那麼濃。要著重在車頂或是引擎蓋邊緣下凹處等雨

水或髒汙容易堆積的地方，同時還要讓整體的色調呈現出濃淡不一，這一點是舊化處理時的小祕訣。車殼的塗裝顏色以兩種顏色調和而成，基本色分別是消光綠色（Flat Green）的Acrylicos Vallejo水性漆以及GSI creos的消光白色（Flat White）Mr.color油性漆。奧川先生在進行模型塗裝時有個習慣，那就是硝基系油性塗料主要都是使用噴罐塗裝，使用畫筆上漆時只使用Acrylicos Vallejo水性漆等壓克力系塗料。向他請教其中的緣由，奧川先生表示：「首先就是噴漆罐在塗裝時絕對是最輕鬆的，不用三兩下就能完成塗裝。而壓克力系塗料的消光程度很不錯，所以就算用畫筆塗裝也沒問題。」基本上，塗裝以後還是要用模型舊化粉處理，所以車殼顏色的塗裝即使隨意一點也無妨。

　車斗上的工具都從FUJIMI的模型組當中挑出的配件。比較大件的貨物由前往後依序是「Doozy Modelworks」1/24比例的石油罐、以樹脂翻模複製廢輪胎零件做成的輪胎。白色鐵桶使用VERLINDEN的AFV配件，地板刷則直接使用美國專門製作1/24比例模型的自宅工作室（garage maker）所販售的商品。雖然奧川先生說：「這些配件就很合適這件作品啦！」但果然還是得經過奧川先生配置，才會有如此的氣氛。另外，奧川先生還把網路上就能搜尋到的「L.L. Bean」、夾在資料夾裡的地圖列印出來，然後布置在車裡。作品當中即使沒有人物角色，這件作品仍將細節劇情表現得淋漓盡致，就連貨車司機的個性也都能略知一二。

　貨車旁的磚牆是這件立體透視模型的配角，製作時先在石膏板表面弄出磨痕，然後雕刻出磚頭形狀，最後再以咖啡色系的壓克力塗料進行塗裝。磚牆上攀爬的爬牆虎則是使用「紙創」的商品「雜草、爬牆虎」，塗裝後再黏接於磚牆上。

Ralph's Service Shop

Baker's Longboard Repair Co.

1/24比例模型（2012年製作）

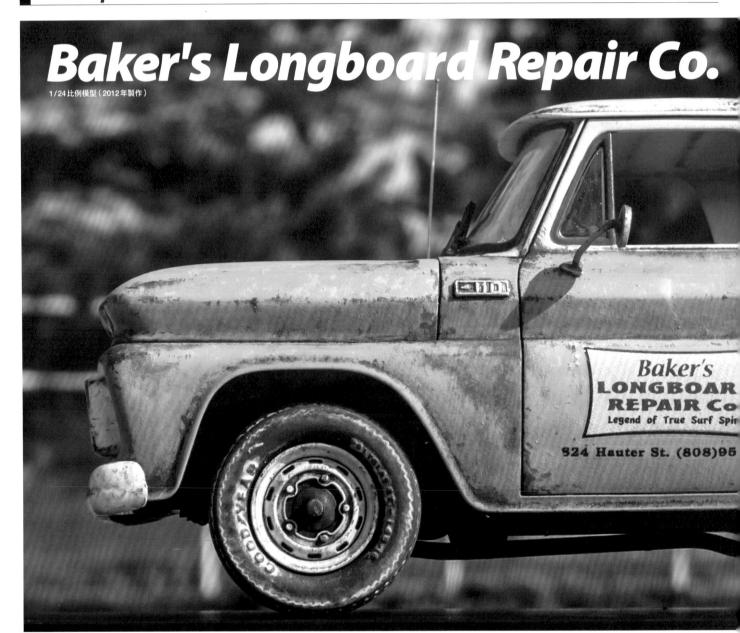

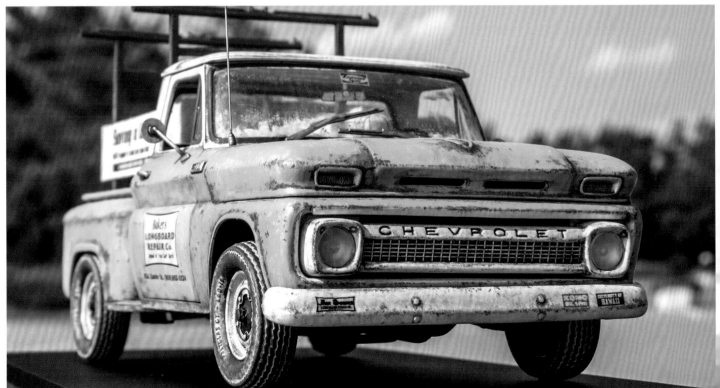

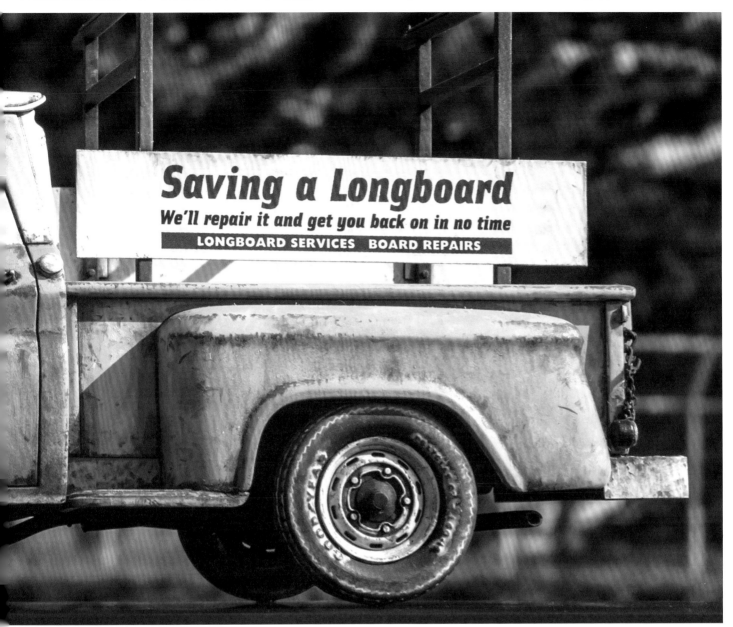

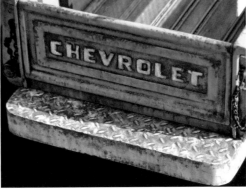

The simple scene showing old surf shop company car. This is created using Revell 1965 year model Chevy Step Side Pick Up.

The charasteristic of cargo is simple using structure of just surf board rack and sign board.

This surf board rack including sign board is made from plastic material, adding the letters in sign board self designed and created decal printed by Okugawa himself.

Truck itself is modelled from original Revell kit, other than detailed accessory chain used to fix at side of the cargo, the design is as from the original kit.

Only parts modified are tires, since the wheels in the kit was so thin, made from molded assembled rubber wheel junk parts in 1:24 scale, same as Tamiya 1:24 Volkswagen wheel.

Reproducing 4 of them from resin and attached. Reproduce tires with resin would not only hard to fix together but unstable to color them, so this is the technique that Okugawa often uses.

Rusts seen in many parts are recreated by pigment using acrylic thinner painted in many parts of this truck, and rubbing off partially with cotton bud soaked with thinner before it dries.

This truck belongs to surf shop so that the dirt is rather heavy. Especially the step part attached to the truck cargo the paint has fallen off by shoes,

showing differences by making upper parts heavy weathering by rust and dirt, and the side part rather light.

Other green fender parts, bonnet hood yield parts, door joints and green parts, where it collects water and parts where people touches has more paint peeled off.

Not just the rust but tyre rubber part has sand enamel paint running, there are appropriate weathering technique used in many parts.

Loads on the car seat are assembled and created using AFV cardboard box kit, gathered by internet and using illustrator to design and built the box.

Map on the dashboard is all created by printing out the data to the paper.

Baseball cap on the dashboard came from ITALERI 1:24 TRUCK ACCESSORIES.

This kit includes the parts related to truck muffler and wheels, other tool instruments and truck driver figures, which Okugawa uses them in his works.

These kits are sold from famous model kit manufacturer other than small resin cast kit brand factory that is run personally, that meets the taste that Okugawa owns.

Those are the parts that frequently used in Okugawa works such as ITALERI parts, Fujimi tooling parts used in 2 kinds of trucks introduced, Diopark garage tool kit and dining table and chairs, cooking tools.

These injection plastic parts and laser cut wooden material or the card board paper parts that Okugawa produces as his own brand, also some scenary parts sold from third party, parts from exhaust nozzle from character models, Okugawa has great taste of making many materials and parts assembled together to express ideal scenery.

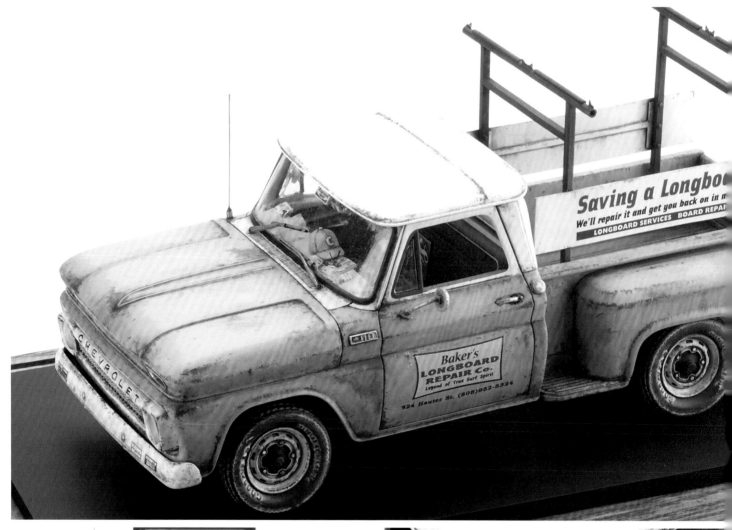

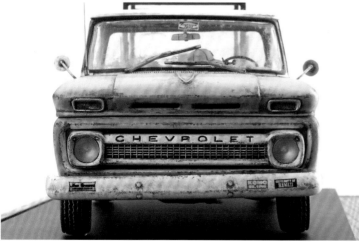

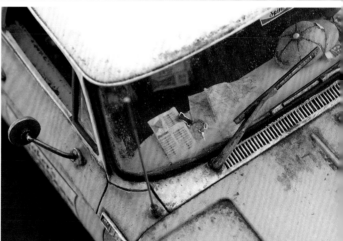

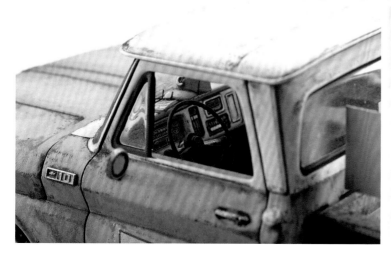

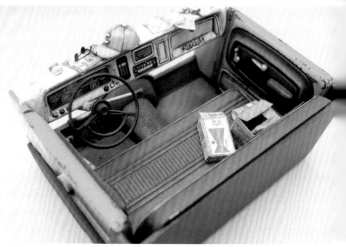

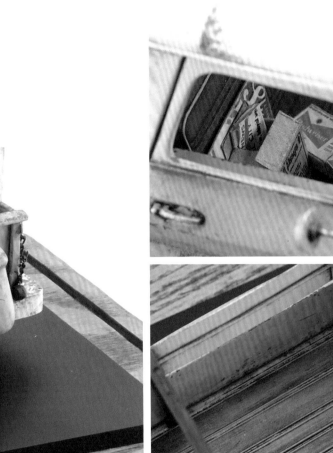
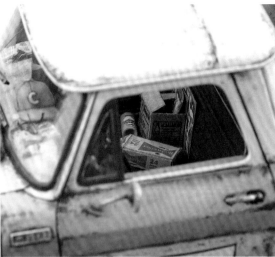
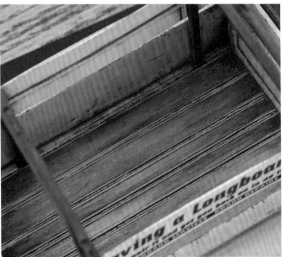
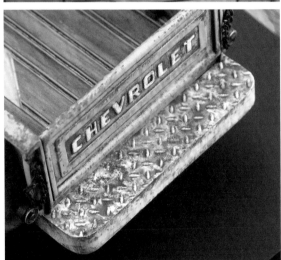

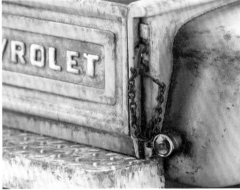
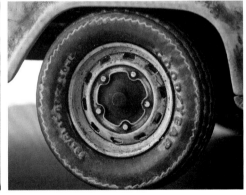

這是一台衝浪用品店的老舊商用車，展現出相當簡樸的風情。這件作品以America Revell 1/25比例的1965年款Chevy Stepside皮卡車為創作基底。車斗安裝了構造簡單的衝浪板車頂架以及看板，簡單而清爽的車斗是這件作品的最大特徵。這件衝浪板車頂架以及看板，全部都是利用塑膠材料組裝而成，看板上的文字是奧川先生自行設計，印成貼紙後再貼上使用。

貨車本體使用America Revell的模型組直接組裝而成，除了在車斗兩旁加上飾品用的鏈條，補足貨車的細節部分之外，其餘可以說都是直接依照模型組進行組裝。唯一稱得上改裝的部分就是輪胎，模型組附的輪胎看起來有些弱不禁風，因此奧川先生使用TAMIYA 1/24比例的福特金龜車模型的鋁圈，以及同樣是1/24比例的故障橡膠輪胎，並以矽膠將這兩樣零件進行翻模，再以樹脂複製出四顆輪胎，才安裝在貨車上。若使用樹脂複製輪胎，原本沒辦法塗裝在橡膠輪胎的塗料就能順利塗裝在複製後的樹脂輪胎，這是奧川先生在作品當中頻繁使用到的技巧。

車體的塗裝先使用液態補土噴塗之後，再塗上GSI creos的天空藍色（sky blue）Mr.Color油性漆。等待塗料風乾以後，再使用研磨海棉砂紙輕輕打磨，露出液態補土的灰色，以表現出車體的褪色狀態。這輛貨車同樣是使用模型舊化粉加上壓克力塗料稀釋液塗在車身的生鏽部分，等待舊化粉差不多風乾時，再使用沾了塗料稀釋液的畫筆或棉花棒搓掉部分的模型舊化粉，重現貨車的鏽痕。這輛貨車是衝浪店的商用車，承受海風經年累月的吹拂，因此各部分的髒汙都有些嚴重。特別是車斗

上的踏板，奧川先生考量到腳踩部分的掉漆會比較嚴重，因此在塗裝踏板時特意將朝上的一面做出多一點的鐵鏽以及汙痕，踏板的側邊則少一些，藉由這樣的處理呈現出髒汙及生鏽的程度差異。除此之外，擋泥板的邊緣、引擎蓋等部位的凹陷處、車頂的接縫或車門的邊緣部分等等，這些雨水容易積蓄或是手經常觸摸的地方都是剝落塗裝時的重點處理部分。不僅是生鏽的部分經過處理，輪胎的橡膠部分也塗裝了大地色系的琺瑯油性漆，針對不同的部分進行相對應的舊汙處理，這項技巧也值得我們多加留意。

車內座椅上的物品是AVF模型專用的紙箱模型組。而儀表板上的地圖、雜誌、香菸等等，全部都是直接貼上列印的圖片。放在儀表板上的棒球帽也是直接使用ITALERI的1/24比例「TRUCK ACCESSORIES」的配件。這組模型組的內容正如其商品名稱，有1/24比例的貨車專用排氣管消音器及鋁圈、各種工具及兜風中的人物模型等等，這些配件也經常出現在奧川先生的作品中。除了這組ITALERI的模型組，以及先前介紹的兩台貨車所用的FUJIMI工具零件模型之外，DIOPARK公司的汽修工具組、餐桌椅組、烹飪工具組等等，都是奧川先生的作品經常使用到的小零件。從這些射出成型的塑膠製模型零件、奧川先生的自創品牌「Doozy Modelworks.」與「cobaanii mokei工房」的雷射切割製的木材或厚紙板零件、其他市售的情景模型專用零件，到製作人物模型的排氣口零件，隨心所欲地組合起各種材質的素材，打造出自己心中理想的風景，這就是奧川先生所擁有的豐富美感。■

Baker's Longboard Repair Co.

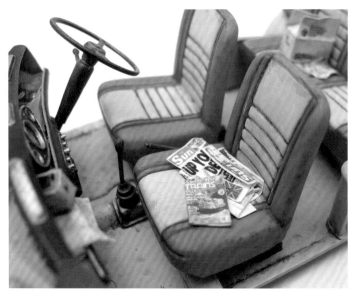

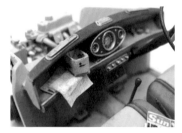

絕對不能錯過儀表板的內部。地圖等等都是不可或缺的物品。

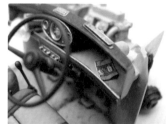

放在儀表板內部的垃圾。這些小東西都是使用列印的圖片製作而成。

分頭進行車內部分的最後修整以及車體的完成作業。奧川先生的作品也特別加強了車內部分的舊化處理，像是座椅凹陷處的陳年汙痕、腳踏墊上的沙塵或是塗料剝落等等，都讓人感受到這台車的使用痕跡。

雜誌、紙提袋、
空瓶等等……
透露出
人類存在氣息的
這些小道具
讓這件作品
顯得更加亮眼

使用剪成小塊的格子花紋手帕製作座椅上的補丁。

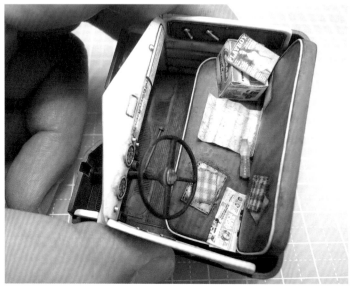

補丁座椅上的報紙、地圖與雜誌等等，都是使用列印的圖片做成的。在分配這些物品的位置時，同時也考慮到色彩的搭配，讓整體的印象不會過於單調。橘色的水瓶使用 1/35 比例戰車模型專用的配件。

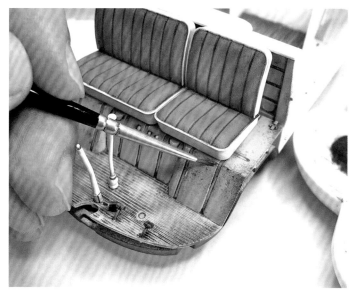

車內仍會出現髒汙或是塗料剝落的情況。處理的方式與車體一樣，邊邊角角的部分使用模型舊化粉加上壓克力塗料稀釋液塗裝，表現出塗漆剝落感。

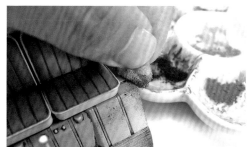

用撕成小塊的海綿沾著模型舊化粉，塗在邊邊角角的部分，做出自然的掉漆痕跡。

透過貨車內部的
舊化處理
表現出
「生活感」、
「有人正在使用」的感覺

演出故事或戲劇性的車內小道具
也是情景模型的展現方式之一

Use small props inside the car to produce drama and story.

從車裡的一件小物品，就能看出車主是如何對待這輛車、這輛車的行駛時間有多長。奧川先生的作品為了重現出如此細膩的感覺，所以就算只是一件汽車用品，也要放入這些資訊。能看出車主個性的小道具的擺設，或是重現車內的汙痕等等，都是奧川先生作品中不可或缺的「表現」元素。

通常提到汽車模型的創作，車內通常都不太會弄得亂七八糟的。不過，車裡放了哪些東西、留下怎樣的髒汙，這些對於我的作品而言都是相當重要的要素。像是這台車開了多長的時間、搭這輛車的人是怎樣的人、這是哪段時期的風景等等，能夠表現出的情報量都會截然不同。即使沒有人物模型在內，也能做出有人坐在車裡的感覺。

所以，車內部分的製作過程不同於跟車體部分，車內的配件、物品都是做好之後才與車體組裝。仔細想想，這些小東西的配置或是舊化處理，其實都跟製作普通的立體透視模型沒什麼兩樣。果然我還是很喜歡這種能重現人類的氣息的創作。（奧川）

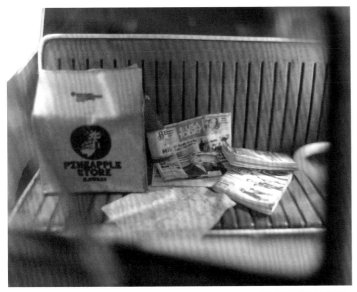

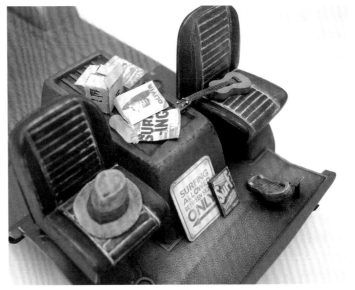

放在座椅上的雜誌、地圖,主要都是使用列印的圖片製作而成。用褐色的薄紙板列印的話,還能自己製作瓦楞紙箱。

車裡的髒汙程度視情況而定。例如:如果貨車停在海邊附近,座椅上的髒汙就要使用像沙子一樣的顏色。

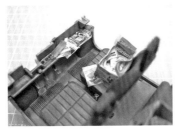

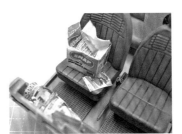

想像一下車主的性格等等,散亂的程度也要稍微有些差異,如此就能讓每件作品有變化性。這張圖片就是比較不散亂的例子。

副駕駛座放了瓦楞紙箱,儀表板上也塞得亂七八糟,看起來真的挺亂的。

紙箱裡面塞了1/35比例模型組的玻璃瓶。

重現了
汽車引擎
或是貨車內部
每個大人
看了都好喜歡

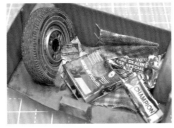

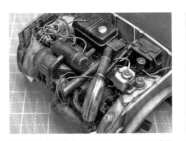

這張圖片是貨車的內部。包含剪成小塊的格子花紋的手帕做成的座椅補丁、備胎、縮小尺寸的汽車用品外包裝。

引擎先塗上桃花心木色塗料,再用黑色或銀色的Acrylicos Vallejo水性漆塗在不同部分,然後以咖啡色系的模型舊化粉製造出髒汙。

Modelers的電線、飛蠅釣專用的細釣魚線、錫線。都是製作電線時使用的材料。

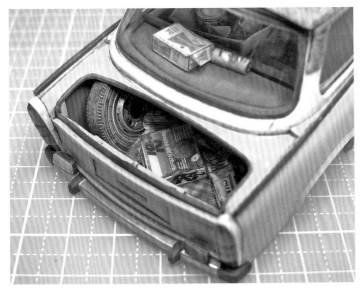

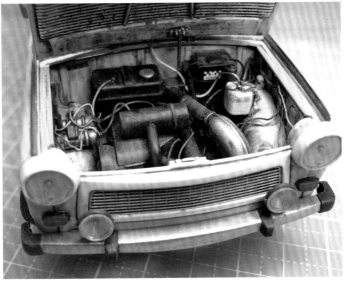

車體裝上了後車廂。大膽地拆開汽車用品的箱子,才做出這樣生動的樣子。後方座位的後面也放了箱子或點心的外包裝,很吸引人的目光。

底盤安裝引擎之後再開始塗裝,是奧川流的塗裝作法。全部塗上桃花心木色的塗料之後,把引擎全部包覆住,再將引擎室內塗上黃色塗料,引擎則另外塗裝,並且進行舊化處理,最後再安裝電線類。

製作擷取部分日本風景的
立體透視模型

Create diorama with framed Japanese scenery.

一直以來，奧川先生發表的作品都是以美國西岸或歐洲為題材。
不過，這件作品的題材卻是SAMBAR小貨車，而且還是「赤帽」
長年使用的那一台紅白色SAMBAR小貨車。奧川先生以這輛完全
呈現日式色調的小貨車為題材，創作出洋溢著昭和風情的沿海風
景。由於創作的題材是身旁熟悉的景色，奧川先生還毅然地前往
逗子、葉山進行取景。奧川先生走在實際存在的沿海小路上，激
發了創作的靈感，於是便有了這一件作品。此件作品不同於奧川
先生一直以來的創作，別有一番風味。希望讀者都能享受這記憶
中懷舊的風景。

Spring 1989
I need to earn money for summer this year
So I started delivery service Akabou as part time job
I want to buy new clothes, go out travel
We know that in fall Bay Bridge will ready to open
No before that I want to get on the Ferris Wheel in Yokohama Expo with Chieko.
Yokohama is moving towards future.
I want to share this excitement with Chieko forever.
Oops I need to concentrate on my driving
There is lot of narrow winding roads around this seaside small town
Yet the road terminates at the back of the town with mountain
I need to hold the goods and run up the stairs
That will make my muscles trained around thighs
But there are also some pleasure
I really like to stop the car by the entrance of the beach
Staring at sea daydreaming during the breaktime
I wonder if the spring afternoon like this, is the wind different to the sea and town
Yokohama where Chieko lives has different senses in the air
Then at once I suddenly missed her voice
She said she will be at home today
I have one spare telephone card
No, I first of all need to finish working
To have fun with Chieko this summer, I need to do my work first
I will be patient to hear her voice until night time

「赤帽1989」1/24比例模型（2013年製作）

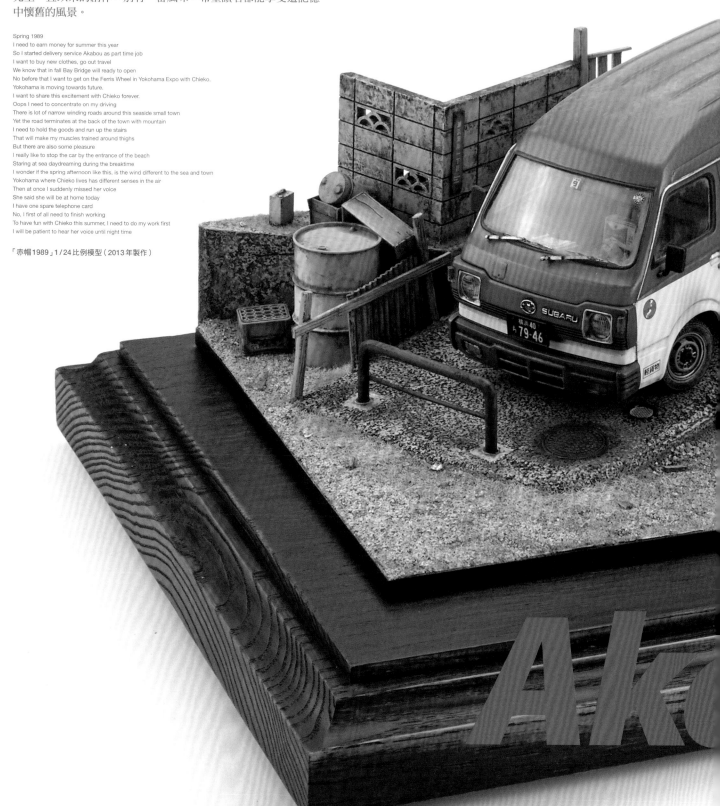

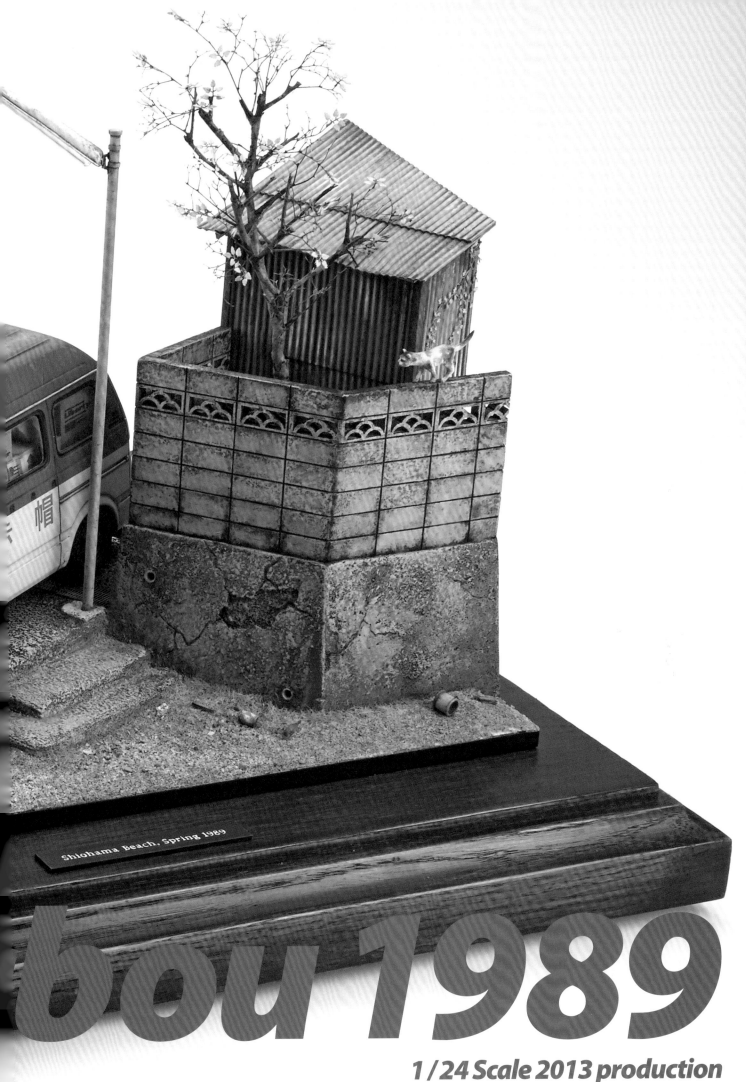

Shiohama Beach, Spring 1989

bou 1989

1 / 24 Scale 2013 production

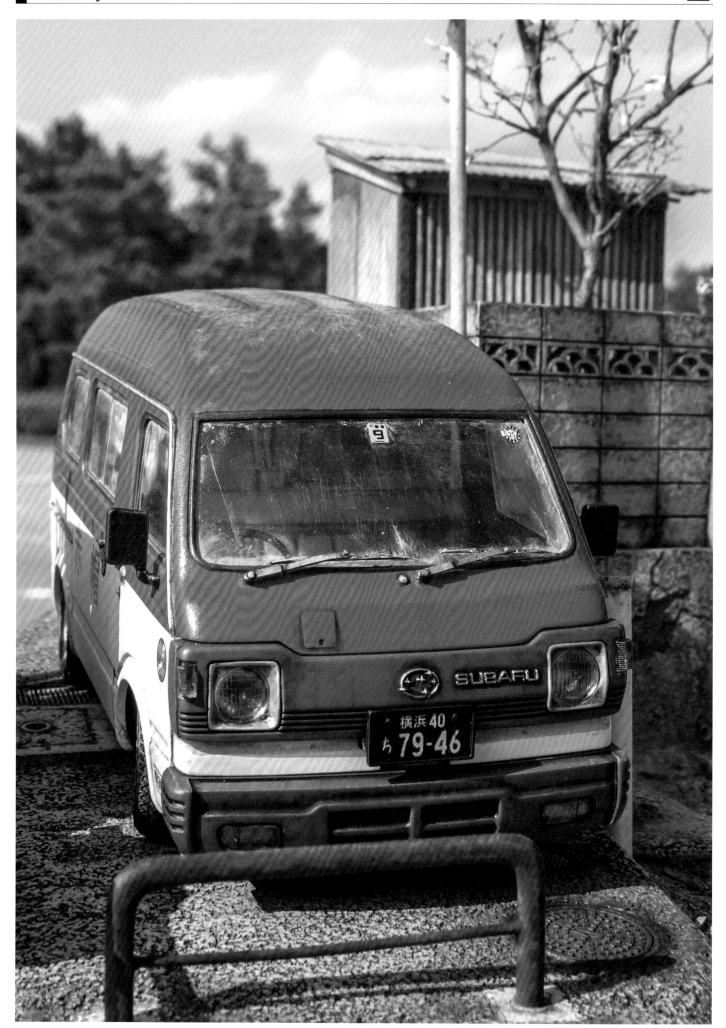

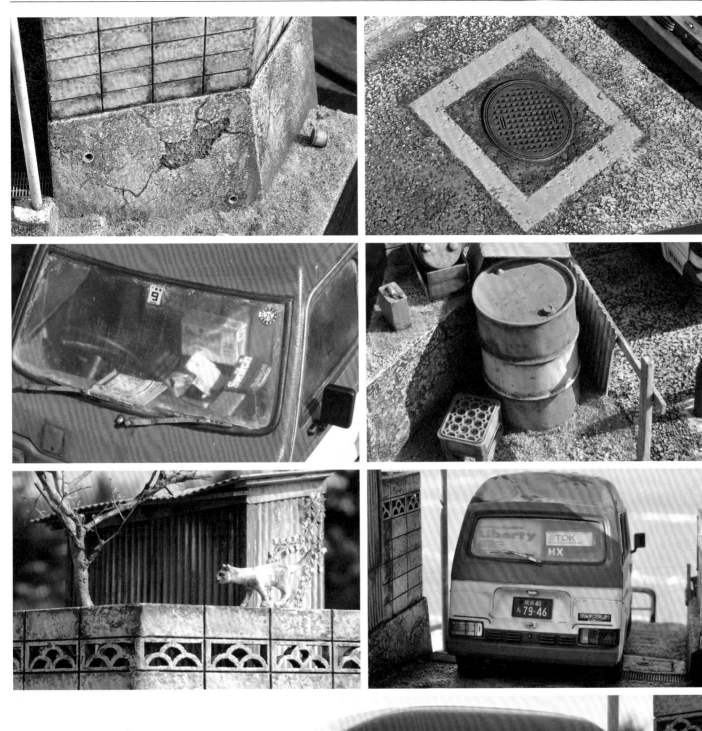

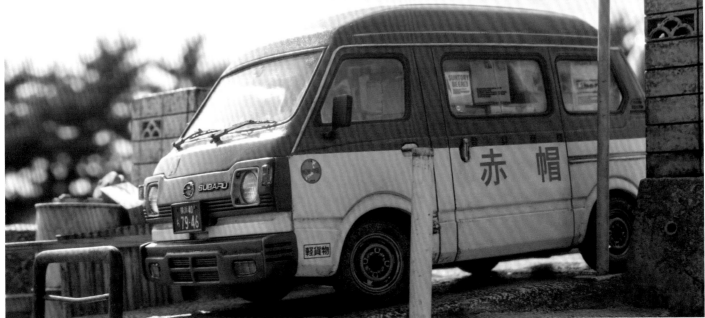

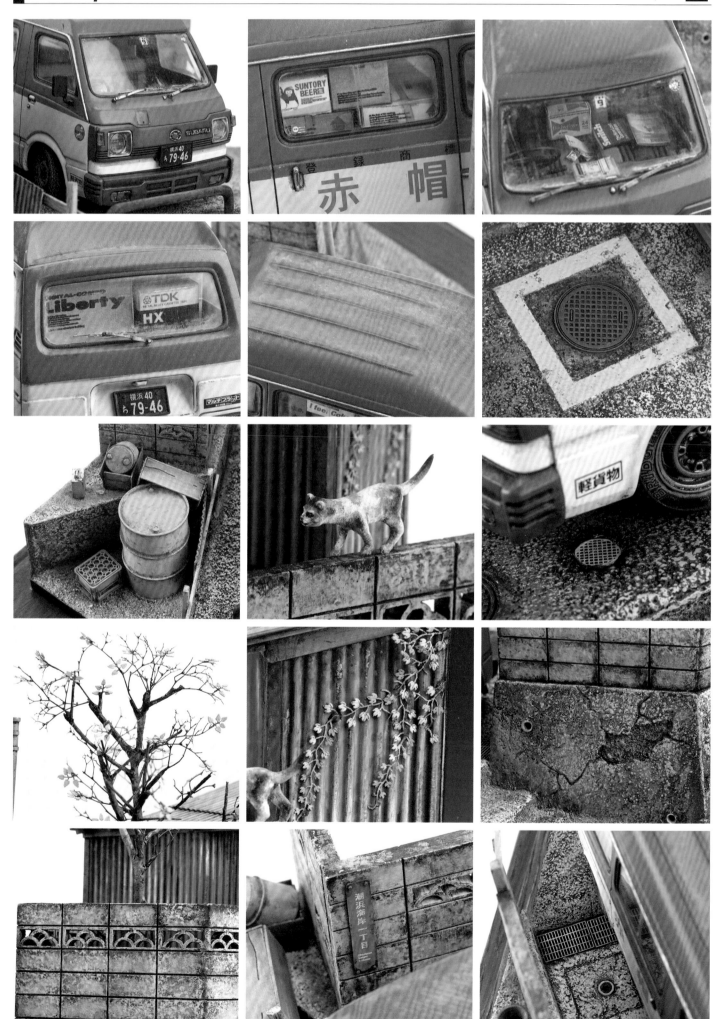

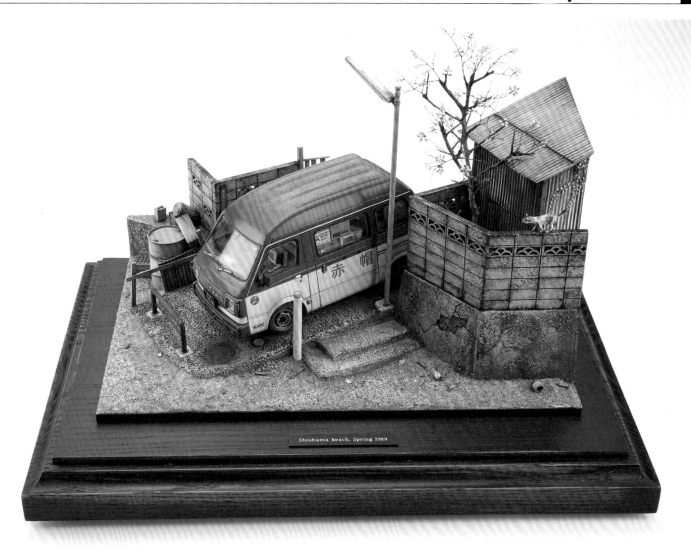

Shiohama Beach, Spring 1989

Spring of 1989, It was his final year as a student. He gave day and night working his part time job.

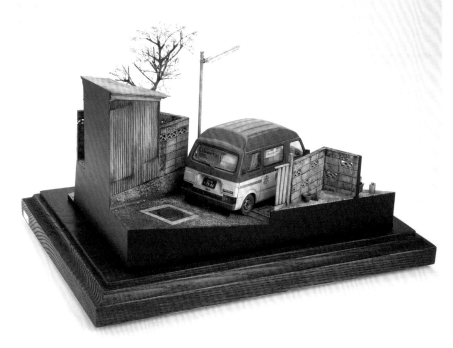

這件作品以日本風情為題材，算是相當難得的創作。在青島文化教材社發售新的1/24比例的模型組時，這台SAMBAR小貨車也同時刊載在「月刊Modelgraphix」與「月刊Armour Modelling」這兩本雜誌的模型製作範例記事。雖說是新發售的汽車模型組，但因為內容物就是SAMBAR小貨車，即使像平常一樣把車體修整得亮晶晶，印象還是會不太一樣，所以我覺得如果在製作這件汽車模型時以舊化處理為前提的話，應該能創造出有趣的作品，於是有了這一件作品的誕生。

模型組裡的商標以及車輪形狀，都是紅帽規格的SAMBAR，所以比起做成全新出廠的樣子，我更想要把這輛車做成實際在工作的感覺，讓人感受到這台車已使用多年，帶給人一種粗獷的印象。而且，要想像出SAMBAR小貨車在遼闊寬廣的風景裡奔馳的模樣也不容易，既然如此，那我就在立體透視模型表現出SAMBAR小貨車在日本的羊腸小徑或是狹窄場地工作的模樣。於是，這件作品便展現了這樣的印象。

難得以日本的風景為題材，因此我也決定前往實地進行取景。畢竟，平常製作的作品都是以美國的西海岸或歐洲的情景為題材，但這些地方也不是說去就能去，所以沒辦法進行實地取景。從這一點來說，日本的小路卻是隨處可見，所以取材算是相當輕鬆。平常沒辦法做到「仔細觀察實物後再製作模型」，但是這次能夠以這樣的方式來創作模型，也讓我覺得很有趣。

風景的取材地點為神奈川的葉山。我從年輕時就經常開車到葉山，這附近有很多在這次的立體透視模型當中出現的小路，其中有些還是朝著大海的方向延伸的斜坡，許許多多的小路構成這一帶的風景。實際到現場取材，拍下許多地點的照片，最後融合這些照片裡的風景融合成一幅景色，大概就是這樣的感覺吧。這件作品使用了第一代「Hang Loose!」剩下的地名貼紙，除了地名是虛構的以外，有相當多的細節都是葉山的風景。

鏤空的磚牆其實形狀相當複雜，所以只有這部分是使用按照圖檔進行雷射切割的MDF密集板，而圍牆的下半部則是珍珠板。路燈的材料為塑膠，鐵皮小屋則是先使用珍珠板組合成四方體，再貼上PLASTRUCT的波浪型膠板。這次創作的素材與之前常用的沒有太大的差別，不過也許是因為是製作日本風景，有別於以往的國外景色，所以創作起來覺得很新鮮。（奧川）

Make the "Akabou" 製作赤帽小貨車

車內的塗裝以畫筆分別塗上不同顏色的 Acrylicos Vallejo 水性漆。

使用 TAMIYA 的墨線液（深咖啡色，dark brown）滲入墨線。

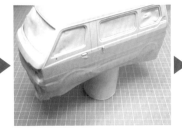

先使用 GSI creos 的 Mr.color 的「白色（white）」噴漆罐塗裝車體之後，再包覆住車體的下半部。

使用 GSI creos 的 Mr.color 噴罐塗裝，顏色為 3 號的「紅色（red）」。

使用泡過水的 180 號耐水砂紙將兩色邊緣的落差磨平。

雨刷使用膠棒及蝕刻片製作。

保險桿另外塗裝德國灰色（GERMAN GRAY）的模型漆，呈現出保險桿的褪色狀態。

保險桿同樣使用墨線液（黑色，black）滲入墨線。

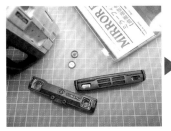

車頭燈的透明燈罩貼上長谷川模型的鏡面貼，讓大燈像是亮著燈一樣。

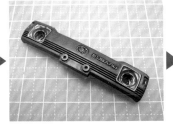

輕輕塗上淺沙色（Light Sand）的 TAMIYA 模型舊化粉彩，打造出立體感。

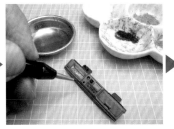

儀表板完成塗裝後，再使用模型舊化粉做出汙痕。

然後使用 TAMIYA 模型舊化粉彩進行乾刷。

安裝車窗的透明零件之前先將邊緣塗黑，藉此表現出車窗的玻璃膠條。

用雙面膠把鋁圈貼在板子上，然後使用 Mr.color 的 8 號銀色的噴罐塗裝。

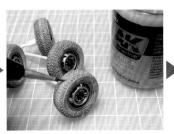

橡膠輪胎的部分同樣利用滲墨技巧塗上 AK Interactive 的「Africa Dust effects」。

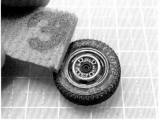

用研磨海棉砂紙磨掉多餘的塗料。

A k a b o

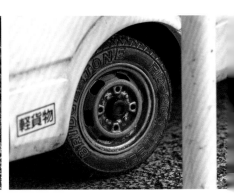

Make the "Akabou" 製作赤帽小貨車

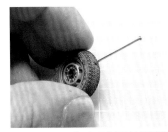

將輪胎釘上固定軸，這是為了以金屬線將輪胎固定在底板。

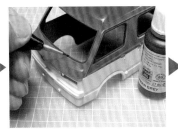

邊緣密封膠條的部分以筆刷塗上德國灰色（GERMAN GRAY）的Acrylicos Vallejo水性漆。

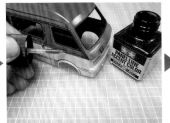

使用墨線液（深咖啡色，dark brown）滲入凹部。

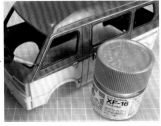

車頂排水槽的部分塗上消光鋁色（Flat Aluminum）的TAMIYA水性壓克力漆。

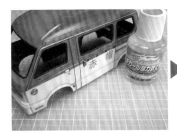

門把等部位同樣進行塗裝，並貼上貼紙。貼紙表面會凹凸不平，使用GOOD SMILE COMPANY的貼紙軟化劑使貼紙服貼。

貼紙風乾後，表面再覆上一層消光壓克力漆。

為了表現出車頂累積的灰塵，刷出痕跡的同時也要塗上AK Interactive的「Africa Dust effects」。

趁塗料還沒風乾之前，先用面紙輕輕沾拭車頂，製造出更多擦痕。

把淡卡其色的模型舊化粉加上壓克力稀釋液，再使用棉花棒輕輕地點塗，表現出沙塵的樣子。

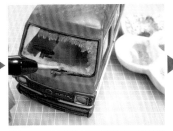

前擋風玻璃同樣塗上加了壓克力稀釋液的模型舊化粉，做出雨水痕跡或灰塵殘留的感覺。

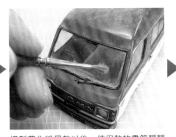

模型舊化粉風乾以後，使用乾的畫筆輕輕刷過擋風玻璃的表面。

車子裡的貨物沒有現成的零件可用，所以以電腦設計圖檔，然後再列印出來使用。紙箱用的是手提袋的紙材。

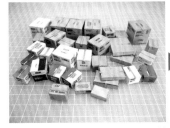

貨物組裝完畢的狀態。封箱膠帶是使用剪成小片的真正封箱膠帶。

把組裝完畢的貨物裝載至車內。

儀表板上的資料夾板使用膠板與銅線製作，夾板上的文件則是列印而成的圖片。

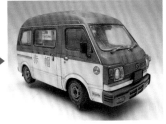

安裝完各部分的配件，完成這台SAMBAR小貨車。

1 9 8 9

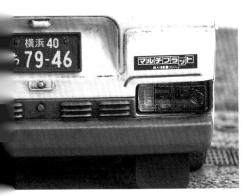

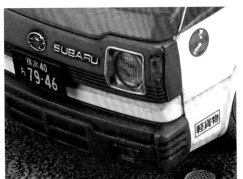

Make the Accessory 製作小物

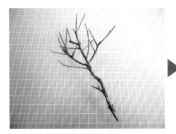

一旁生長的樹木為真正的樹枝，使用 TAMIYA 的白膠黏貼組合而成。

剪開乾燥花的前端，製作細樹枝。

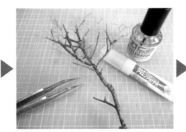

使用膠狀的瞬間接著劑與硬化促進劑，將樹枝黏接在樹幹上。

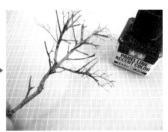

樹木塗上深咖啡色的墨線液，讓墨線液滲入木頭。

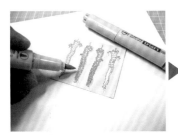

葉子使用「cobaanii mokei 工房」雷射切割的爬牆虎。裁切之前先使用模型舊化粉著色。

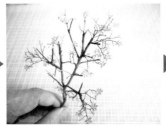

將葉子固定在樹枝前端。

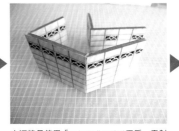

水泥牆是使用「cobaanii mokei 工房」雷射切割的 MDF 密集板。

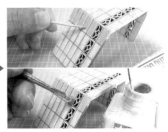

用牙籤塗上膏狀模型補土，再使用筆刷塗上液態模型補土，打造出粗糙的質感。

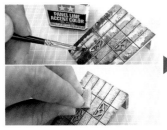

把已經做出凹凸感的表面滲入墨線，再用研磨海綿砂紙輕輕磨掉塗料。

使用裁切好的珍珠板組合成四方體，做成鐵皮小屋的內殼。

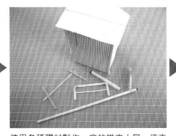

使用各種膠材製作一旁的鐵皮小屋、停車擋板、路燈，並將鐵皮小屋的內殼貼上塑膠製的浪板。

鐵皮小屋先使用 Acrylicos Vallejo 水性漆稍微塗裝。

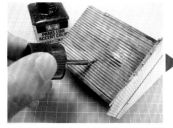

想像雨水殘留在鐵皮上的痕跡，使用深咖啡色的墨線液做出水痕。

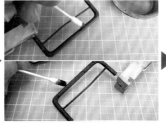

用棉花棒塗上咖啡色系的模型舊化粉，描繪出生鏽的樣子，再塗上深咖啡色的墨線液，加強整體的印象。

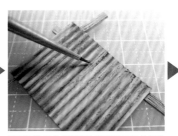

使用紅棕色的模型舊化粉描繪浪板凸起的部分，畫出生鏽的痕跡。

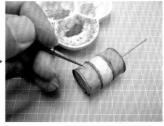

原油罐也塗上加了壓克力塗料稀釋液的模型舊化粉，打造出鐵桶的生鏽痕跡。

A k a b o

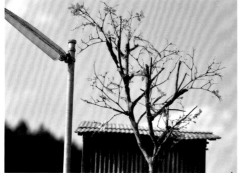

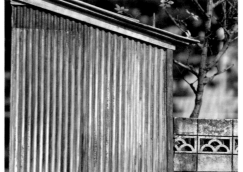

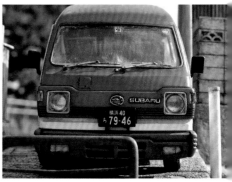

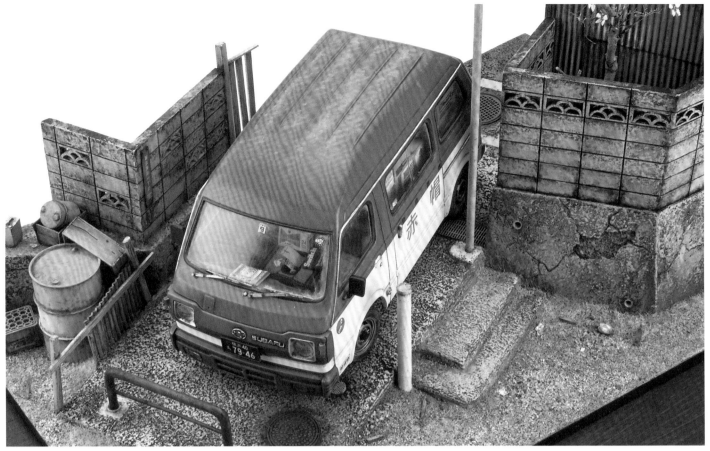

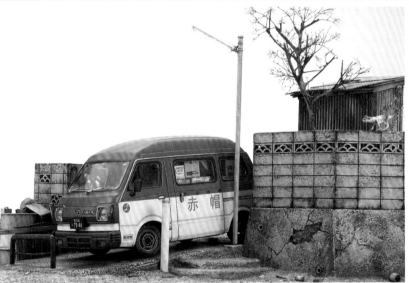

Among the work Okugawa creates, this "Akabou 1989" has absolute Japan domestic scenary , without any US taste included.The model is Sambar that actual "Akabou" delivering company uses for business, which is definitely Japanese. Diolama that is unique from other works.When talking about Subaru Sambar you cannot ignore presence of "Akabou"Sambar used for Akabou was designed and produced dedicated for Akabou to meet the requirement in severe delivery business.Sambar was used in all Akabou that lead to mass demands, then the operation in Akabou made Sambar the long life car model and used long period as co☒ercial vehicle.This diolama was created when the Subaru Samber 1:24 scale model was released from Aoshima, planned as joint issue in"monthly Model Graphix" and "monthly Armour Modeling" "If the subject is Akabou Sambar then the work should not be brand new shiny car, but the rugged vehicle that are used in everyday business" Plan started with the used practical vehicle scenery recreation. Also the theme for this vehicle diorama applied the situation where the location Sambar was used in Japan which happened to be decided as Hayama in Shonan area. Location where continuous slope exist towards the sea, and the blocked walls and old buildings with galvanized-iron roof, Hayama scenery is most appropriate place for Sambar."Broad scenery with not so many buildings" are not quite suit Sambar, Hayama was the perfect location to fit in diorama.Even though this diorama express traditional Japanese scenery, the material and technique used in Okugawa works are co☒on in other works.For instance, how to make galvanized-iron roof and the block walls are described from page 6 in "Hang Loose!" which are the same methods You will notice that the drum cans placed by the road are the same one as used in other works, from Dooze Modelworks. Also the material and the technique used in Sambar weathering are almost the same as that of other car modeling (in this book the works described from page 20).The scenery used as subject has co☒on taste even though it represent last period of Showa in Japan which is traditional Japan to the other works that Okugawa owns as style.
These genius taste of work are presented by Okugawa despite of what subject he selects as a scenery.

1 9 8 9

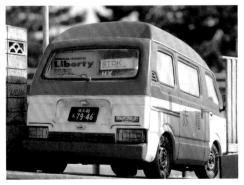

Make the Ground 製作地面

以裁好的厚紙板組裝起臨時底板及建物，確認整體的布局。

使用珍珠板及保麗龍板製作底板。

柏油及水泥的部分塗上粗浮石凝膠。

粗浮石凝膠變硬後，使用研磨海綿砂紙稍微磨掉表面凹凸的顆粒。

畫筆沾取TAMIYA立體情景模型塗料的「泥土，深大地色」塗裝水泥牆面。

塗料變硬後，一樣用研磨海綿砂紙輕輕磨平。

牙籤沾取TAMIYA膏狀模型補土，填補水泥部分。

使用液態模型補土，以畫筆點塗在表面，表現出粗糙不平的感覺。

階梯表面看起來過於平面，所以用鑷子戳出一些小孔洞。

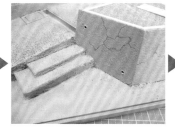

使用鉛筆打草稿，畫出水泥部分的裂痕。

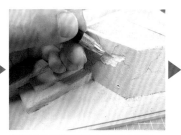

沿著草稿線以筆刀剔除水泥部分的表面。

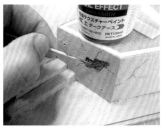

用牙籤將TAMIYA立體情景模型塗料「泥土，深大地色」填補在被剔除的水泥部分。

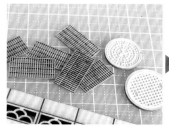

人孔蓋、馬路中間的水溝蓋以「cobaanil moke工房」雷射切割的零件製作。

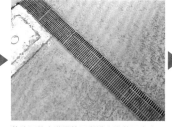

將路面的水溝調整至與排水溝蓋同寬度，再使用瞬間黏著劑黏接。

同樣將人孔蓋黏在馬路旁。

把紙黏土鋪在底板上，做出沙灘地微微起伏的樣子。

A k a b o

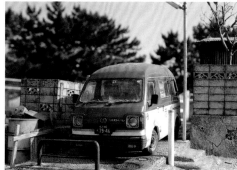

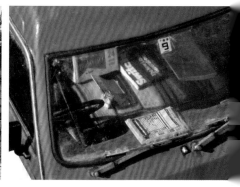

Make the Ground 製作地面

用筆桿在紙黏土表面壓出小小的凹凸，藉此呈現出沙灘的地面形狀。

紙黏土變硬後，用畫筆大致在表面塗上液態模型補土。

柏油的部分使用自然灰色（Natural Gray）的 Acrylicos Vallejo 水性漆，以筆塗的方式進行修飾。

人孔蓋使用暗鏽色（Dark Rust）、自來水管栓使用天空藍色（Sky Blue）的 Acrylicos Vallejo 水性漆塗裝。

製造刷痕，一邊大膽地塗上黑色的墨線液。

風乾後使用 400 號的研磨海綿砂紙輕輕地打磨表面，露出打底的灰色塗料。

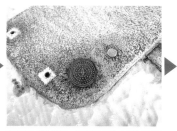

馬路完成的樣子。看得出馬路中間被研磨海綿砂紙磨得較細緻。

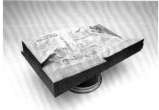

修整完柏油的部分後，再用紙膠帶包住底板上方，將底板側邊噴上黑色塗料。

圍牆與馬路的接合處塗上淺青苔色（Slimy Grime Dark）的 AK Interactive 效果表現塗料，以此增加青苔。

使用雕刻刀將填上紙黏土的部分削出弧度，重現油罐桶陷進沙灘的樣子。

塗裝 TAMIYA 的立體情景模型塗料「砂石，輕砂色」，重現圍牆旁的地面。

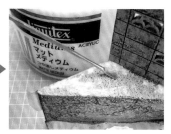

隨意地在沙地塗上消光輔助劑，用來固定草皮。

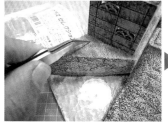

使用立體透視模型專用的草地素材「GLASSES SELECTION」，以鑷子夾取一小束的綠草，黏在塗上曙光輔助劑的部分。

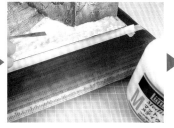

再使用塗料調色棒將沙灘塗上消光輔助劑。

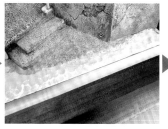

撒上情景模型專用細沙，使細沙固定在逐漸風乾的消光輔助劑上。

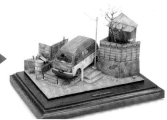

將事先插好固定輔助釘的 SAMBAR 小貨車、建築物及木頭固定在保麗龍做成的底板，完成立體透視模型。

1 9 8 9

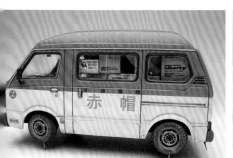

葉山的風景，大海就近在眼前，走下斜坡馬上就是沙灘。這一帶的建築物都不高，也讓人印象深刻。

藉由實地取材所展現的真實感
「Akabou 1989」實地取材紀錄

Record of "Akabou 1989 " location scouting. Covering the real thing for the true reality.

季節是春天，小路的盡頭是遼闊的大海。
這是奧川先生為「Akabou 1989」設定的舞台背景。
而位於神奈川縣的葉山的風景，正好能滿足「小路連通至沙灘的巷弄風景」的條件。
生鏽的人孔蓋、地形變化、水泥製品的質感等等細節，
都是從真正的葉山風景獲得靈感，才能打造出這件作品。

以前，我就住在逗子與葉山的附近，所以出門兜風時經常會開車前往逗子、葉山。於是，當我決定製作SAMBAR小貨車的立體透視模型時，自然而然就想到以這附近的風景為舞台背景，當成是模型的創作題材。

平時的作品題材都是美國等地方的風景，所以與這些景色比起來，日本的街道反而是我們更加看慣的風景。不過，也不是每個人都會特意留意日本的街道模樣。所以，我想要讓人一看見這台小貨車就會驚呼「啊！我知道這個！」。只不過，一旦模型的質感或配置與實際上的樣貌有些微落差，別人馬上就會看出這件模型與實際上的樣子還是有所不同。因此，當製作的模型是「眾所皆知的題材」時，要是一切都順利的話，光是這一點就足以成為最大看點，只不過真正做起來還是有些困難。

因此，我在製作這件SAMBAR小貨車的景觀模型時，就連自己拍攝的照片也是以細節部分為主。我很慶幸能近距離觀察人孔蓋的生鏽狀態、水溝蓋的安裝方式、木材的風蝕狀況等細節部分，這些都是在平常的作品當中無法達成的，所以我真的覺得很開心。（奧川）

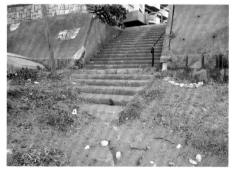

被海砂覆蓋的水泥階梯。如果立體透視模型也呈現出這模樣，應該會很有趣。

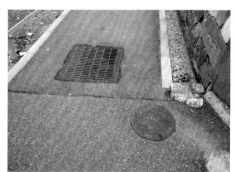

人孔蓋或水溝蓋生鏽的質感也是不容錯過的細節。

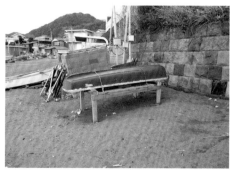

被拉上岸的小艇。把這艘小艇當成創作元素，應該會很吸睛吧。

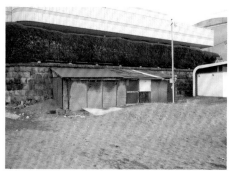

在海邊的鐵皮捲門沒多久就生鏽了。如果能在景觀模型裡重現的話，或許也會引人注目。

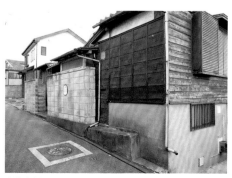

木牆塗漆剝落的感覺、水泥圍牆以及建築物下方的青苔。質感的對比顯得很有趣。

發現掉漆的人孔蓋。或許也可以在情景模型當中重現。

這條排水溝只有最旁邊使用其他規格的排水溝蓋，應該是長度不合的緣故。這也是我想放進模型裡的細節部分。

海邊的水泥路面斑剝不堪，拉著繩索的柱子也倒了。這幅景象看起來沒什麼，卻透露出相當多訊息。

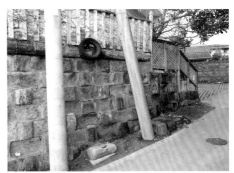

斜坡路上帶著歲月痕跡的石壁。不過這裡為什麼掛著輪胎呢？

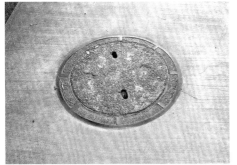

髒汙顯得挺壯觀的人孔蓋。這是相當好的舊化處理參考資料。

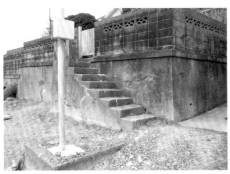

明明都是水泥做的建築物基底，因為是不同的部分，呈現的顏色也截然不同，看起來很有趣呢。

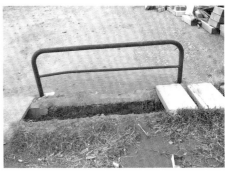

完全生鏽的停車警示柱。製作模型時也能當成質地呈現的參考。

油罐桶的生鏽感很不錯。用繩子跟旁邊的電線桿綁在一起才不會翻倒，真有趣。

製作方式很簡單的一盞路燈。或許這麼平凡無奇的模樣放在立體透視模型當中才會更有路燈的感覺。

鐵鏽外露的護欄，可以注意一下上半部與下半部的鐵鏽落差。

在通往海邊的小路盡頭的停車警示柱。情景模型加入這項元素就會變得更不一樣。

通往海邊的階梯。水泥色調的變化或階梯邊緣部分的剝落，都是不錯的參考。

看板上繪製了葉山的海岸規定。木製柱腳的塗漆剝落狀態看起來很不錯。

同一面看板的背面。看得出支撐看板的木材根部的邊邊角角已經腐爛，顏色也變得不一樣。

水泥製的側溝蓋也出現了裂痕。這些卡在縫裡的灰塵垃圾，我也想透過塗裝的方式來重現。

蓋在海邊的咖啡廳。氣氛很好的一間店，所以忍不住就拍了這張照。

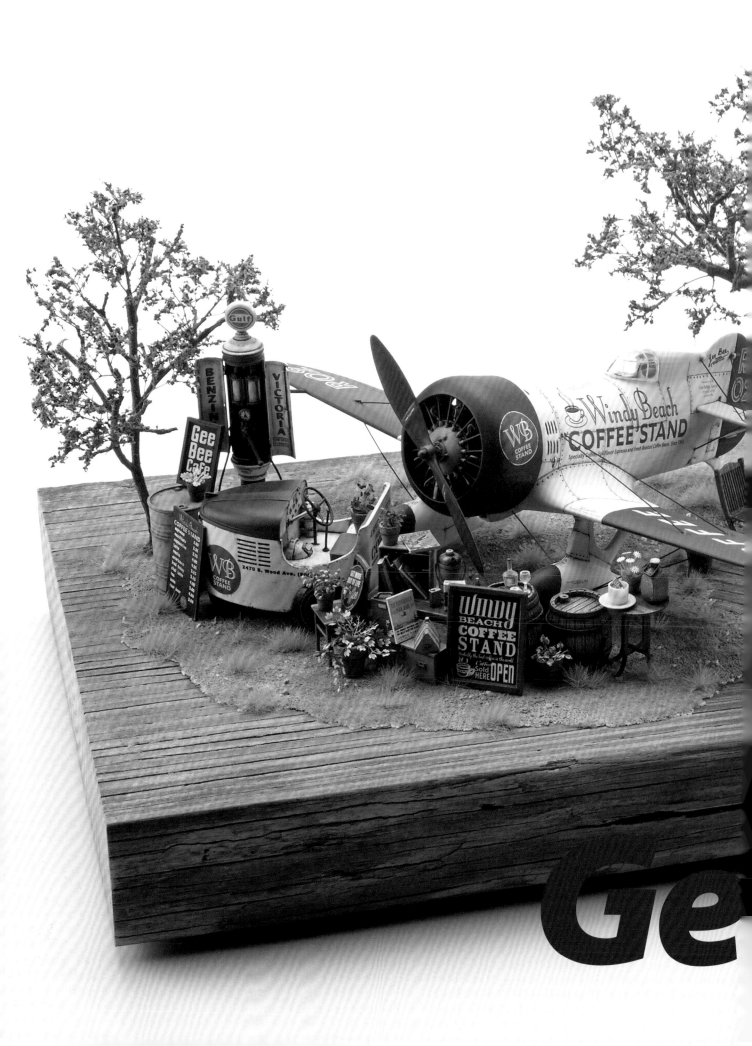

製作以飛機呈現出非日常空間的 立體透視模型

Utilized the unusual space with aircraft for the diorama.

我的許多作品都是以汽車模型為題材，然而在眾多的作品當中，就有這麼一件是照著以飛機模型為主題的書進行的創作。這件立體透視模型的創作題材，正是1930年代初期活躍於美國的 Gee Bee 競速飛機的其中一款型號「Model Z」。跟普通的飛機模型相比，這架飛機在這一件作品當中，可說是不費吹灰之力地讓人一眼便看出它所扮演的角色——這架 Model Z 竟是位於海邊的景觀咖啡廳的招牌看板！這一架作為招牌看板的飛機，便在此度過它的餘生。以1930年代的競速飛機作為店家招牌的景色看起來雖有些突兀，但奧川先生在創作過程連細節部分也運用了各種素材進行組合，作工精緻細膩的立體透視模型不由得讓人覺得很有說服力。這件作品可說是以高超水準將「要是有一間這樣的咖啡廳……」的想法付諸於實際的立體透視模型。

When I walk up the sand shore I see an airplane up in the hill
I climbed up the short stairs and came close by
And found out that it was a café.
I never thought to use Gee Bee Racer as display board
What a owner to have a fancy idea
I sat on a chair by a table and lit a cigarette
At the tip of the propeller continues the sea shore
And beautiful blue shining horizon
When I look across there is a shed same white and brown coloring as the plane
There are space in the kitchen and shed where you can drink coffee
See the pretty logo mark in red written in white by the roof
Now the ice coffee is here
I sipped once and lit second cigarette
Beach named windy must be always windy
But this afternoon breeze is good and made drinking straw in the drinking glass
Sway a little
I was staring at the sea for a while
And lit the third…. , better not
I have to tell her about this café as soon as I see her
What would she say?
I suddenly want to finish up my plan and see her smiling face
Smiling face with dimples
Then the strong wind passed by, once.

1/32 比例模型（2015年製作）

e Bee Cafe

1/32 Scale 2015 production

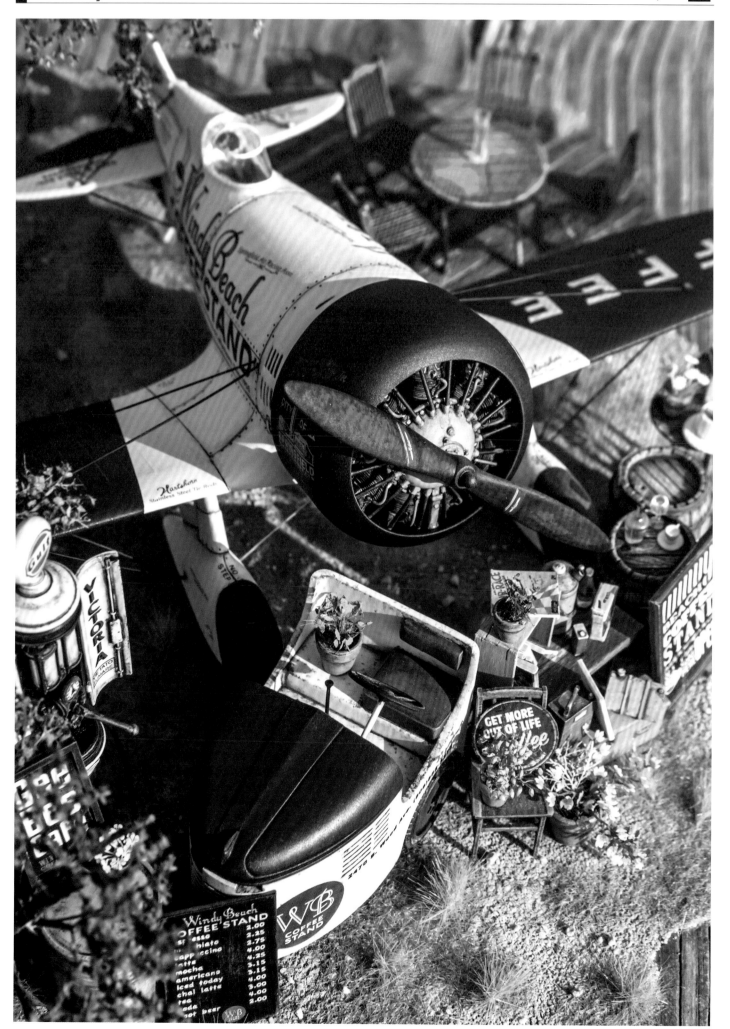

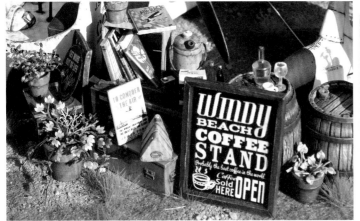 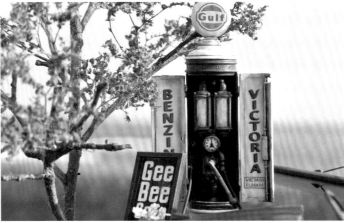

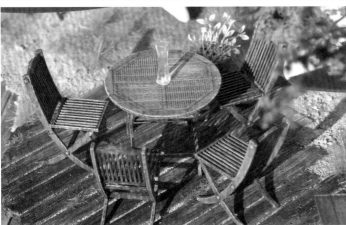 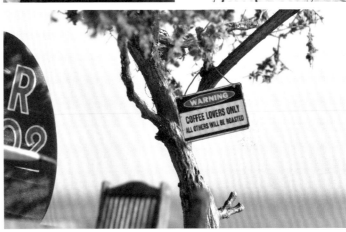

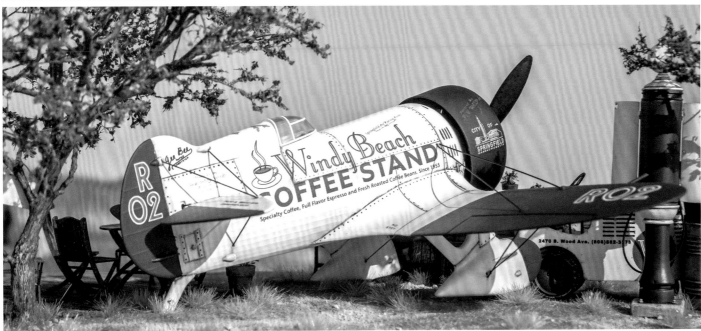

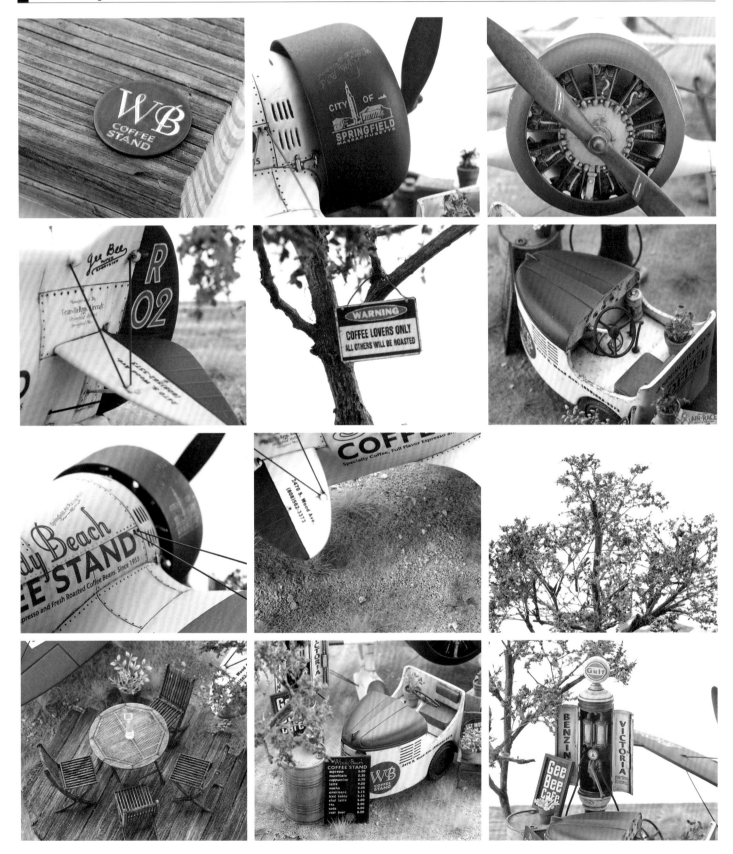

重新雕塑了模型，並在引擎加上電線等，但基本上還是以Williams Brothers模型組所呈現的感覺完成這一台Gee Bee競速飛機。各部分的貼紙都是以Illustrator製圖再列印而成，只有垂直尾翼上的「R02」是直接使用德軍戰車的提示專用貼紙。停在一旁的後推車則是按照本來的組裝方式所組裝的「SWASH DESIGN」樹脂灌模製模型組，並且使用與Gee Bee競速飛機相同顏色的塗料。旁邊的桌、椅使用「cobaanii mokei工房」雷射切割的材料組合而成。後推車一旁的加油機使用Model Victoria的GK模型組。其餘的則是使用自製的素材或各種模型的剩料等等達到效果。本件作品當中包含了許多固定使用的素材，像是MiniArt的模型組附的木酒桶、以膠版製成的點菜板、使用製作人物模型的排氣孔做成的花盆，以及使用鐵路模型專用的草木素材做成的盆栽植物等等。

Would you like a cup of coffee while looking at this airracer?

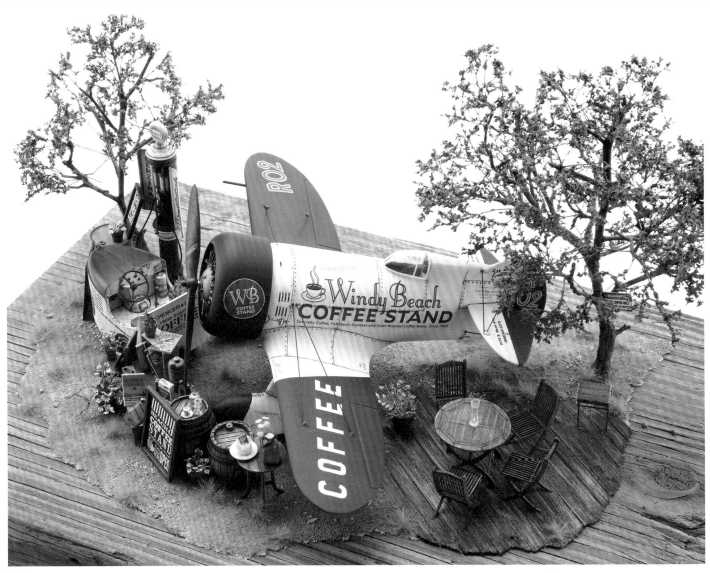

Surrounded with my fasvorite things.
The best way to spend my afternooon.

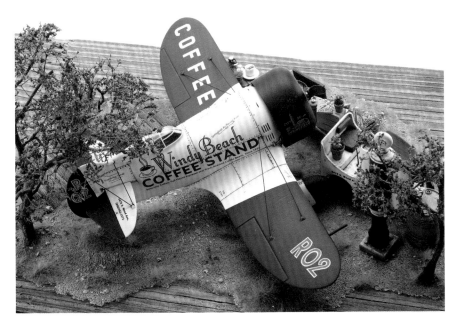

這件作品是為了刊登在以飛機模型為主題的雜誌書（MOOK）而製作。雖然我平常好像不太製作飛機模型，但真的以飛機為題材的話，其實我還挺喜歡的，以前也做過TAMIYA的1/32比例的F-14雄貓戰機。我高中時其實想當一名航管員，所以我當然也知道這架Gee Bee競速飛機，在我決定「就用飛機當成創作材料之一」時，腦海裡就浮現了這架飛機。

要說這件立體透視模型為何設定成這樣的風格，其實就只是覺得：「做成普通的Gee Bee競速飛機的話，我可沒那手藝啊……」我覺得單純地組裝Gee Bee競速飛機的模型，未免太無趣了一點，倒不如把這架飛機變成是符合我的作風的材料，於是我的腦海裡便浮現出「已退役的Gee Bee競速飛機搖身一變，成了海邊咖啡廳的看板」的樣子。這個想法成形之後，接下來一切都好辦了。

Gee Bee競速飛機當中有好幾款機型的形狀都長得挺類似，這件作品當中使用的是Model Z。Gee Bee競速飛機最有名的是Gee Bee R1、Gee Bee R2等機身較圓潤的機型，Model Z的機身則是比這些機型更纖細一些，這一點是Model Z的特徵。原本，我打算使用LINDBERG發售的1/32比例的Gee Bee R1飛機，不過因為這組模型算是比較早期的商品，到處都買不到。後來決定改買Williams Brothers的1/32比例Gee Bee R1，結果發現Williams Brothers的模型組變得非常貴，所以最後終於決定用Model Z製作。

這件作品除了飛機以外，許多其他要素都與別的作品相通。例如：1/32比例的桌椅是使用「cobaanii mokei工房」雷射切割的材料，這是我在作品中常用的素材；飛機旁的後推車則是我的損友齋藤MASAYA所負責的「SWASH DESIGN」發售的樹脂製模型組。我的品牌「Doozy Modelworks」在模型組的製作方面承蒙了「cobaanii mokei工房」的關照，我和齋藤又同在一個模型製作圈，所以也讓我使用了那一些人脈。除此之外，像是使用人物模型的零件製作的植物盆栽、MiniArt的1/35比例的木酒桶、草木素材等等，基本上都是使用與其他作品一樣的材料，所以就算是製作不同以往的題材，感覺起來還是一如既往的創作風格，讓我覺得安心不少。偶爾嘗試製作一些視覺效果不同的創作，其實也是挺有趣的呢。（奧川）

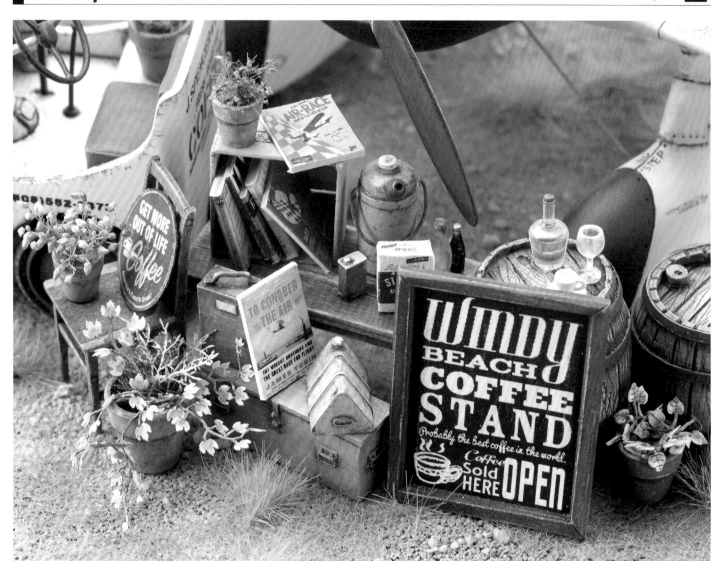

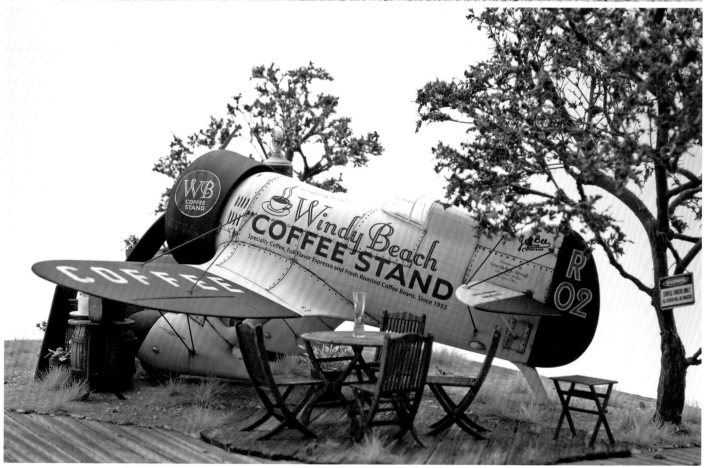

This work was run as an article in airplane model subjected mook. Airplanes are not frequently used as his work subject, infact he used to create F14 Tom Cat model 1:32 having almost the same technique that of expert airplane modeler.

Okugawa has certain preference in airplanes, but thought it would be boring if he just created airplane plastic models for this work as it is.

So what he had in mind was to match it to use small Gee Bee Racer as café sign board and place it in European open café scenery, which is his favorite performance, dragging the scenery in his own world using airplane model as material. What he selected in this work for Gee Bee Racer, was model Z among other several types.

This has slightly slim shape compare to the famous models such as R1 and R2 which is much rounder in shape.

At the time of creating this model, it was intended to use 1:32 scale R1 from Lindberg, but the model kit was too old to assemble,he intended to get 1:32 model kit from William Brothers. But nowadays this William Brothers kit is really a precious rare model that he had model Z instead and started creating the work.

Other element used in diorama has all well-reputed supporting roles well known in Okugawa works.

Tables and chairs set in 1:32 scale are from Cobaanii Mokei Kobou, which is in sworn ally position to develop collaborative kits.

The tug car parked next to the plane belongs to the resin cast kit by SWASH DESIGN produced by Masaya Saito.

Masaya Saito also belongs to the same modeling club and has unco⊠on technique, which means this work has most of the abilities using his personal connections fully.

Diorama structure also has a twist inside. What matches with the rectangle base is the island shaped layout, which makes the impression tight and

packed for the airplane diorama but made effective to make open from stiffness impression. Also by adding goods in front part of the plane placing the high trees in rear part, the density considering the angle of whole highs and lows of diorama is calculated.

All elements are expressed avoiding extremes; here the most experienced tendency can be identified in the scenery created using airplane as a difficult subject for diorama.

這件作品的最大特徵就是整件立體透視模型的構圖。底板使用的雖然是庫存的舊木板，地面的配置方式卻很值得一瞧。奧川先生並未將整片木板都規劃成地面，反而在底板上半部留下大片的空白，只取一小部分的木板空間做成地面，並讓這架擔任主角的飛機斜斜地停在這片地面上。若是將一大片木板直接做成無任何起伏的地面，就算之後再怎麼注意各個配飾的配置，最後還是會變成平淡無奇、感受不到緊張感的展示而已。為了避免這樣的情況，奧川先生大膽地將舊木板留下空白區域，打造出悠閒的氛圍，同時卻在立體透視模型的本體濃縮飛機、桌子、看板及後推車等要素，呈現出緊密的樣貌。配置的疏密程度在立體透視模型之中一直都相當重要，而這一件作品展現出了足以作為教科書教材的絕佳平衡感。奧川先生至今已創作許多的立體透視模型，其中也包含以AFV模型為題材的作品。這件作品所展現的絕妙平衡感可說是只有經驗如此豐富的奧川先生才辦得到吧。

Still resembling the time in the air with the dignified stance.

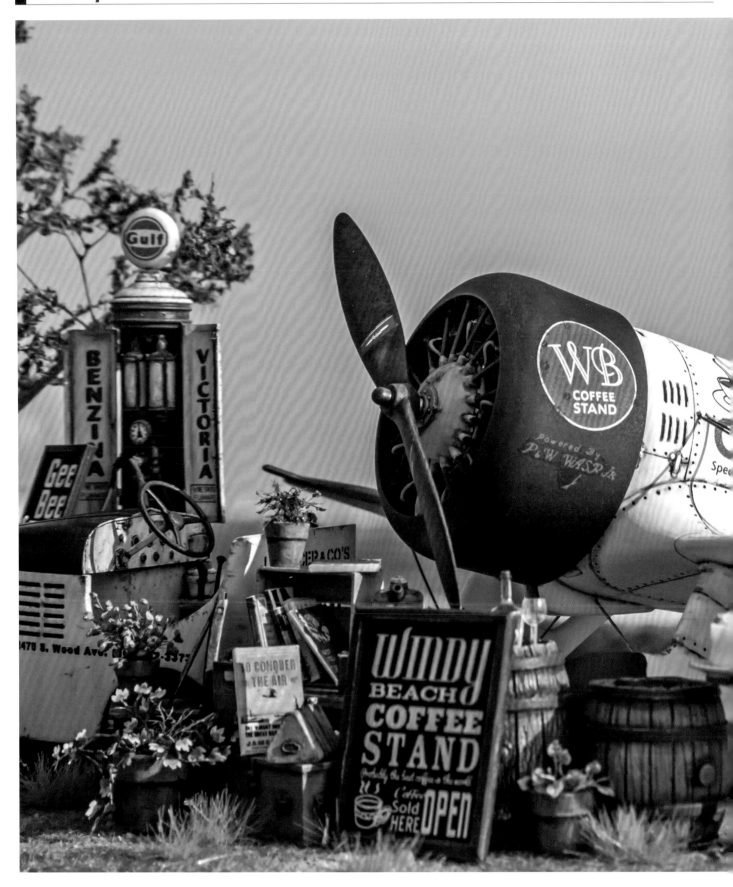

After stop flying,
the GB is working every day as the poster girl airplane.

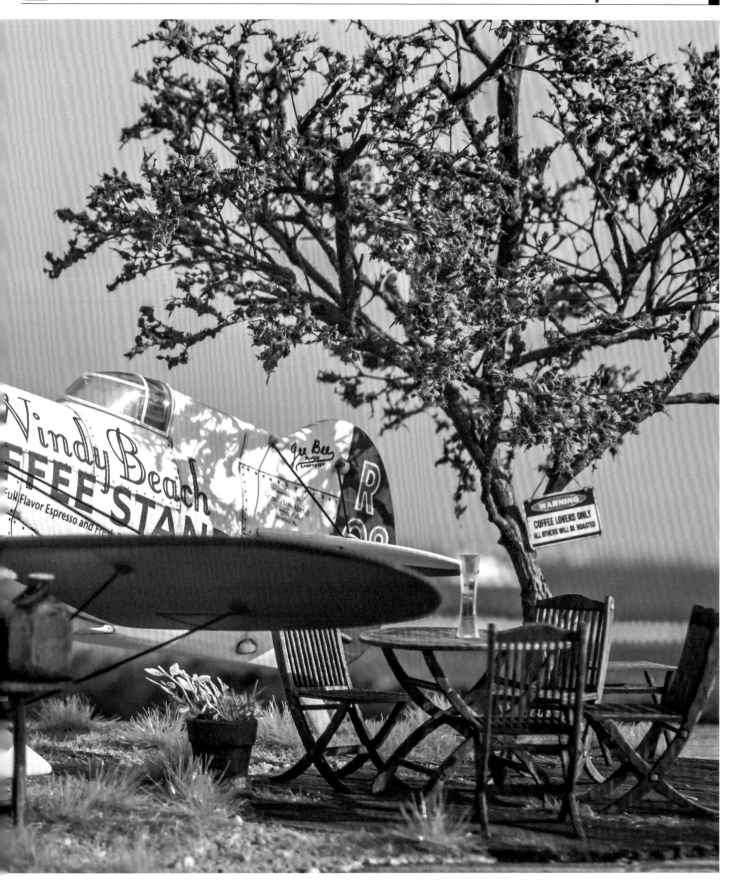

The Granville Gee Bee Model Z was an American racing aircraft of the 1930s, the first of the Super Sportster aircraft built by Granville Brothers Aircraft of Springfield, Massachusetts, with the sole intent of winning the Thompson Trophy, which it did in 1931. However, it soon suffered a fatal crash during a world speed record attempt, starting the reputation of the Gee Bee aircraft as killers.

Suffering from the effects of the Great Depression, the Granville Brothers decided in July 1931 to build an aircraft to compete in that fall's Thompson Trophy competition at the National Air Races in Cleveland, Ohio. They hoped that a victory in the prestigious race would lead to additional orders for their line of sporting aircraft.

Constructed in less than five weeks at a cost of under $5,000 USD, the Gee Bee (for "Granville Brothers") Model Z, named City of Springfield, was a small, tubby airplane. It was essentially the smallest possible airframe constructed around the largest possible engine, a supercharged Pratt & Whitney R-985 "Wasp Junior" radial engine, producing 535 horsepower (399 kW).

倒在千葉海岸邊的百威啤酒空罐。氣氛很不錯,所以就拍下這張照片。我記得這大概是三十年前的照片。

灑落在看板上的樹蔭看起來真好。

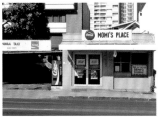

日本似乎沒有這種顏色的建築物。

這張是在逗子拍的照片。影子斜落的方向跟看板的紅色都很不錯。

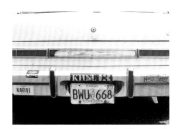

車牌旁邊貼了FM電台的標籤貼紙,看起來很時髦。

我很喜歡這種藍色與黃色的顏色對比。

椰子樹、海灘的旗子還有白雲。在這個構圖完美的地點按下了快門。

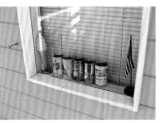

位於七里濱的某家店的窗戶。這家店也已經收起來了。

看板的掛法、擺設方式,這樣就是一個廣告了呢。

在家裡拍的照片。我覺得浮現的白色、靛藍色與紅色很不錯。

這張也是在家裡拍的照片。大概是心裡想去哪裡走走吧。

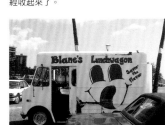

行動餐車。車身的插圖真可愛。

用奇怪的姿勢看書的女孩。這張也是在夏威夷拍的照片。

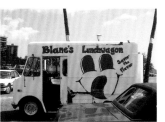

Chapter 5

一窺奧川泰弘的內心世界

深 深 影 響 著 奧 川 泰 弘 的 事 物 、 地 點 與 回 憶 是 ?
What was Yasuhiro Okugawa's influences

1980年代的廣告、美國西海岸、湘南、常春藤大學、汽車……
這些事物都帶給奧川先生深遠的影響
透過奧川先生自己拍攝的景物
解析他融入在各個作品當中的要素

我太喜歡紅色了，所以這張也是忍不住按下快門的照片。

怎樣都離不開大海與沙灘。

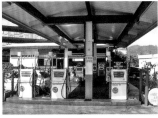

「76」加油站。我很喜歡空氣中飄著汽油味的風景。

以前的房間。努力地把它改造成一間帶著美式風情的時髦房間。

車牌與上面的貼紙形成的對比相當生動有趣。

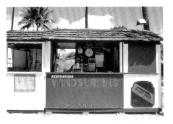

風帆衝浪店的鐵皮小屋，顏色搭配超級棒。

三十年前左右的橫濱。藍色的天空令人心曠神怡。

下雪時在簷廊下拍的照片。也很有廣告的感覺呢。

路肩的紅色形成很好的對比色。車子似乎不能停在這個紅色區域。

夕陽真的最棒了。

早已關店的餐廳「Weather Report」。外國的包裝看起來很有魅力吧。

沙灘上的衝浪板。如果把這張照片加上標題和文案，就可以直接當成一張海報。

位於根岸的美軍住宅區的消防局的石油鐵桶。模板複印的英文字真不錯。

我喜歡灑落在金龜車上的樹蔭，所以拍下這張照片。

你們知道拿著電燈照著空瓶子的下方就會變得很漂亮嗎？

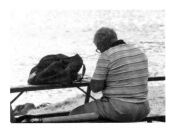

在夏威夷海灘上的老爺爺。沒什麼大不了，就是覺得這個氛圍很不錯。

撞上路燈的汽車，就直接停在這裡不移走。顏色的對比同樣很不賴。

灑落在馬路上的椰子樹影。是一張視覺效果很棒的照片呢。

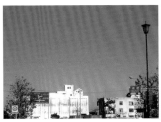

三十年前左右的新港碼頭。那時候我常去那兒。

乍看之下以為又是在國外，其實這是千葉的海邊拍的照片。

倒映在玻璃窗上的風景以及一旁的綠意，形成了有趣的對比。

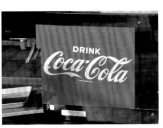

又是紅色。一看見可口可樂的看板，就忍不住想拍下來。

舊電影院。藍色的天空與外牆、看板的顏色形成了很好的對比。

無止盡的高速公路。這張照片同樣也可以直接當成明信片。

　　我原本就非常的喜歡1980年代的廣告感。不僅呈現出商品的優點，還完整地表現出整個世界觀，只有那個年代才做得出這麼棒的廣告。所以，我特別抵擋不住呈現出這種感覺的物品，就連在製作模型或是像這樣拍照時，也不自覺地模仿起廣告的感覺。在這兩頁放的照片當中，有好幾張照片只要加上一點廣告文宣、商品圖片或商品資訊，就可以直接當成廣告或是明信片。下一頁關於雜貨之類的照片也是如此，感覺年輕時接觸到的美國以及平面設計的世界，都成為了自己血肉之一部分了呢。（奧川）

我覺得很酷的漢堡店的名片、廣告傳單、衣服的標籤。我會把喜歡的東西全部保留下來。這是因為身為一個設計師，這些小東西都可以當成是工作時的參考資料。

F-1賽車熱潮時買的雜誌。我很喜歡這個設計。

因為設計的工作而拿到的音樂教室宣傳小冊子。我超喜歡這本冊子的文字的排列。

實在太喜歡了，所以真的買了一台。

為藝術家JEHO設計的粉絲後援會專屬會報。是一份很開心的工作。

也為音樂家堂島孝平設計了粉絲後援會專屬會報。設計時相當自由呢。

讓人一看就不可自拔的雜誌《POPEYE》。

替FM yokohama設計的免費宣傳品。

至今為止做了相當多與音樂相關的廣告傳單的工作。

很喜歡八〇年代後半的《Switch》的文字排列或是排版。

扶桑社的《18℃》，是一本很時尚的雜誌。我也想做做看這樣的書。

我超喜歡美國警察。從以前就在蒐集刊載了美國警察的裝備或制服的雜誌。

大家都知道的渡瀨政造先生的漫畫。我想在作品裡做出這樣的氣氛。

為數眾多的雜誌、雜貨，似乎沒什麼大不了的日常記憶都在他的情景模型當中點綴上了色彩

Many magazines, sundries and memories of ordinary days are coloring his diorama works.

多年以來蒐集的美國的雜貨或包裝。

超喜歡可口可樂的LOGO。我還蒐集了25周年、50周年的紀念瓶。

這些也是美國的雜貨。果然不能少了美式橄欖球的周邊小物。

我也買了很多美國製的玩具。

第一次去夏威夷時帶的NIKON F301與FA相機。這兩台相機我經常使用。

還有很多的徽章。貼在夾克之類的地方也很不錯吧。

現在已經找不到的紙板火柴。我把設計不錯的都保留下來了。

我覺得外型很酷,所以衝動之下就買了這台NOKIA手機。

如果馬克杯上有喜歡的LOGO,我都會蒐集。結果蒐集了這麼多。

美國的電力工程專用工具包,不過因為外型很時尚,我都把它當成一般的包包在用。

看到喜歡的玻璃瓶或是鐵罐也會買下來。最右邊的是玻璃瓶造型的時鐘。

這些也是雜貨。汽車用品的瓶罐等物品是製作時重要的參考資料。

很久以前就開始蒐集的別針徽章。

我從高中開始就很憧憬常春藤大學。

迷上看《POPEYE》也是在高中左右。喜歡的東西從以前到現在都沒什麼改變。

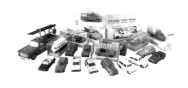

1/64比例的迷你小汽車。雖然稱不上收藏家,也一點一點蒐集了這麼多。

一直以來都受到片岡義男先生的小說影響。

之前做客機的機內清潔打工時拿到的活動徽章。

我自己其實不玩橄欖球,但還是收藏了一顆。

高中時觀賞的音樂劇的手冊。讓人熱血沸騰。

「VAN」的商標。一提到常春藤風格,就是這樣的感覺吧。

我曾經想當一名航管員。這本是《Airline》的創刊號。

以前就有的關於諾曼地登陸的書,我從小學開始就很喜歡軍事領域。

波斯灣戰爭時買的胸章。現在的我不知道那時候為什麼要買這個。

 這裡放的照片都是我從國、高中時期就一點一滴收集起來的雜誌或是雜貨之類的東西,還有少部分是我在當平面設計師時負責設計的工作,簡單來說,這些東西都成了我在創作模型的源頭,各位應該一眼就能看出我真的很喜歡1980年代的世界觀或是美國文化吧。雖然每一樣物品之間看起來沒什麼脈絡可循就是了。立體透視模型的底座上的標題文字、汽車的車身側面塗裝的看板文字的字體排版、店名的命名方式等等,我覺得這些雜誌或是雜貨的設計都帶給我相當多的影響。(奧川)

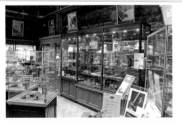

本書刊載奧川泰弘先生製作的情景模型。讀者還可以前
往位於大阪築港的紅磚倉庫的老爺車博物館「GLION
museum」之中的「K's Collection」，購買本書當中
的某些作品。這間「GLION museum」為嶄新模式的
老爺車博物館，甚至可以在這裡購買展示的老爺車。位
於其中一隅的「K's Collection」除了奧川先生的作品
之外，平時還會展示約八百種左右的最新迷你汽車模
型。另外「GLION museum」還附設了牛排館、咖啡
廳等飲食空間，五官感受皆能享受到經典車款以及高檔
的成熟氛圍。各位讀者造訪大阪時務必大駕光臨。

I decided to make them by myself, and I established Doozy Modelworks.

景觀模型の創造與製作3

Landscape Creation 3

著者／奧川泰弘

ランドスケープ・クリエイション 3
All Rights Reserved
Copyright @ Yasuhiro Okugawa 2016
Original Japanese edition published by Dainippon Kaiga Co., Ltd.
Complex Chinese translation rights arranged with Dainippon Kaiga Co., Ltd.
through Timo Associates, Inc., Japan and LEE's Literary Agency, Taiwan.
Complex Chinese edition published in 2021 by Maple House Cultural Publishing

出版／楓書坊文化出版社
地址／新北市板橋區信義路163巷3號10樓
郵政劃撥／19907596　楓書坊文化出版社
網址／www.maplebook.com.tw
電話／02-2957-6096
傳真／02-2957-6435
翻譯／胡毓華
責任編輯／王綺
內文排版／謝政龍
港澳經銷／泛華發行代理有限公司
定價／380元
初版日期／2021年1月

國家圖書館出版品預行編目資料

景觀模型的創造與製作. vol.3 / 奧川泰弘作；
胡毓華譯. -- 初版. -- 新北市：楓書坊文化出
版社, 2021.01　冊；　公分

ISBN 978-986-377-649-9（平裝）

1. 建築美術設計　2. 景觀藝術　3. 模型

921.2　　　　　　　　109017398